PERMISSIONS, A SURVIVAL GUIDE

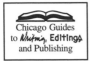

Chicago Guides
to *Writing*, **Editing**
and Publishing

On Writing, Editing, and Publishing
Jacques Barzun

Tricks of the Trade
Howard S. Becker

Writing for Social Scientists
Howard S. Becker

The Craft of Translation
John Biguenet and
Rainer Schulte, editors

The Craft of Research
Wayne C. Booth,
Gregory G. Colomb, and
Joseph M. Williams

Glossary of Typesetting Terms
Richard Eckersley, Richard
Angstadt, Charles M.
Ellerston, Richard Hendel,
Naomi B. Pascal, and
Anita Walker Scott

*Writing Ethnographic
Fieldnotes*
Robert M. Emerson, Rachel
I. Fretz, and Linda L. Shaw

Legal Writing in Plain English
Bryan A. Garner

From Dissertation to Book
William Germano

Getting It Published
William Germano

A Poet's Guide to Poetry
Mary Kinzie

*The Chicago Guide to
Collaborative Ethnography*
Luke Eric Lassiter

*Doing Honest Work in
College*
Charles Lipson

How to Write a BA Thesis
Charles Lipson

*The Chicago Guide to
Writing about Multivariate
Analysis*
Jane E. Miller

*The Chicago Guide to
Writing about Numbers*
Jane E. Miller

Mapping It Out
Mark Monmonier

*The Chicago Guide to
Communicating Science*
Scott L. Montgomery

Indexing Books
Nancy C. Mulvany

Getting into Print
Walter W. Powell

*A Manual for Writers of
Term Papers, Theses, and
Dissertations*
Kate L. Turabian

Tales of the Field
John Van Maanen

Style
Joseph M. Williams

*A Handbook of Biological
Illustration*
Frances W. Zweifel

Permissions, A Survival Guide

BLUNT TALK ABOUT ART AS INTELLECTUAL PROPERTY

Susan M. Bielstein

The University of Chicago Press CHICAGO & LONDON

SUSAN M. BIELSTEIN is executive editor for art, architecture, classical studies, and film at the University of Chicago Press.

The University of Chicago Press, Chicago 60637
The University of Chicago Press, Ltd., London
© 2006 by Susan M. Bielstein
All rights reserved. Published 2006
Printed in the United States of America

15 14 13 12 11 10 09 08 07 06 1 2 3 4 5

ISBN: 0-226-04637-0 (cloth)
ISBN: 0-226-04638-9 (paper)

This book provides a wealth of information about copyright and other areas of intellectual property law, but it is an information source only. This book and its recommendations should not be construed as legal advice or as a substitute for consultation with a knowledgeable attorney in any particular circumstance.

Library of Congress Cataloging-in-Publication Data

Bielstein, Susan M.
 Permissions, a survival guide: blunt talk about art as intellectual property / Susan M. Bielstein.
 p. cm.
 Includes bibliographical references and index.
 ISBN 0-226-04637-0 (cloth: alk. paper)—ISBN 0-226-04638-9 (pbk.: alk. paper)
 1. Copyright—Art—United States. 2. Copyright licenses—United States. I. Title.
 KF3050.B54 2006
 346.7304'82—dc22
 2005034161

For Anthony Burton &
Kimberly Pence, the real experts

Contents

Acknowledgments

THIS LITTLE book began life as a conversation. Or I should say, as conversations, many of them over the past twenty years with hundreds of people: editorial colleagues and faculty here in Chicago; rights and permissions specialists around the world; other publishers; and last, but certainly not least, more than a few attorneys.

What induced me to sit down and actually write it, though, were the urgings of authors whose works I've had the privilege to publish. I offer this book to them as a bedtime story, to be taken in the evening with a cup of tea or stiff drink close at hand. Read straight through, from beginning to end, it explores how intellectual property law applies to the visual arts. It further examines how the character of modern intellectual property law is always shifting and adapting to social, cultural, and economic change, and what recent developments in practice bode for the future. So prop up with a couple of pillows at your back, my friends, and read until your head nods. May my prose lull you into dreams of a sweeter, less turbulent time to come.

Of the many people who have shared their experience of acquiring rights to visual images, I give special thanks to David Freedberg, Sheila Schwartz, Leo Steinberg, Hollis Clayson, Anita Duquette, Lee Greenfield, Rachael Delue, Eve Sinaiko, Dave Hickey, Timothy Gilfoyle, Sally Chappell, Mary Sheriff, John Beldon Scott, John Nicoll, Gillian Malpass, Deborah Kirshman, Terry Smith, Micaela di Leonardo, Caroline Jones, Patricia Rubin, Laura Letinsky, Vivien

Fryd, Joel Snyder, Stephanie Moser, Garrett Stewart, and photo sleuth extraordinaire Jill Shaw. Thanks also to the artists who have supported this enterprise by allowing their work to appear in the book at little or no cost: Jeff Koons, Rod Northcutt, Elizabeth Cook, John Sparagana, and Satori Gregorakis.

I am honored that Linda Halvorson, editorial director for reference books, wanted this book for the Chicago Guides to Writing, Editing, and Publishing series published by the University of Chicago Press. She quickly recognized that visual intellectual property has its own brace of perils, practices, and potential for change and was worthy of book-length discussion. The care she devoted to the manuscript's development made it far better than had I written it without her guidance. I appreciate that the Press pulled out all the stops to edit this book and get it to market. I am especially indebted to the team that made it happen: the unflappable Chris Rhodes, who juggled hundreds of details related to review and publication; Erin DeWitt, who is such a gifted editor; Matt Avery, expert designer; Joan Davies, production controller; and Ellen Gibson, creative marketeer.

My deepest gratitude goes to those who read the book in various drafts and made so many helpful suggestions: Erin Hogan, Dorothy Johnson, Adrian Johns, Martha Ward, Theodore Feder, Susan Rossen, Sarah Hoadley, Jeffrey Cunard, and Peter Jaszi. Thanks, too, to Perry Cartwright, Michael Brehm, Sylvia Hecimovich, and Jill Shimabukuro for reading and commenting on sections of the text as well.

My greatest interlocutor on the subject of permissions has long been Anthony Burton, a colleague and friend whose experience and wisdom I treasure. To him, and to Kimberly Pence, who made so many of the photographs that appear in this book, I warmly dedicate it.

1 ✻ Permissions, A Love Story

SHOULD YOU ever find yourself magically alone in the administrative wing of one of the great libraries, publishing houses, or art institutions that grace the city of New York, you might want to tiptoe past the director's office in favor of a brisk walk down the hall, past the offices occupied by the usual satrapy: the managers of finance, security, and community affairs, then a bit farther on, the librarians or editors or curators, each of whom works in a habitat smaller than the one before as their luster diminishes in direct proportion to their distance from the director's door. As the light in these far reaches grows dimmer, dimmer, you may find you have to squint a little as you thread your way ever on, past the washroom, taking care not to stumble over the janitor's bucket. When you reach the last door, yes, that one—the blue one at the end of the hall—don't bother to knock, just enter.

You are now inside the fun house—or chamber of horrors, depending on your view. Perhaps you've been here before? If so, welcome back. If not, you'll find this is a world in which the fragile distance between a belly laugh and a Munchian scream can dissolve in a blink. It is the world of intellectual property, and this is a rights and permissions office. There are rules, but they don't always mean much; laws, but too broadly written. It's a world of perceived sides: yours versus theirs, a universe of fine lines and split hairs. It is a world that seems equitably divided between victims and bullies. One party's gain means another one's loss. In this world, you survive by wit and patience.

This book is about intellectual property. In particular, it is a book about publishing art books, generally conceded in today's market to be an act of love, not gain. It is about living in thrall to the image. But in today's world, one must have permission to love. This is a book about permissions, about a whole world of permissions and how, if not exactly to thrive in it, at least to endure.

To be sure, most of us will never set foot in a rights office or be privy to what actually goes on behind the blue door, but that doesn't preclude us from being bound up in that world, however distant and arcane it may seem. What must one know, then, in order to negotiate the permissions culture of our time? What permissions does one need to publish a beloved work of art?

Generally, two kinds:

1. *Copyright permission* if the work is still in copyright and has not yet entered the public domain (more on this anon)
2. *Use permission*—that is, permission from the institution or person who can furnish a reproduction image of the artwork for you to use in your publication

Oh, and of course, you must have an image that will reproduce well in a printed medium. One would think this a given, but it's amazing how many people don't understand this fundamental necessity.

These, then, are the three key topics of this book. (1) *Copyright:* what it is and how to determine if a work still enjoys legal protection under copyright law. (2) *Use:* the broad legal implications of the term and how to cope with them. (3) *Image:* acquiring the actual image in a format that will reproduce well using current technologies of reproduction.

But before we proceed, a disclaimer. Here's what this book is not: it is *not* a definitive tract on copyright law. Instead, it's a practical text rooted in legal fundamentals and anecdote. The narrative travels here and there, from topic to topic, in an effort to be instructive by way of example. Good ones, bad ones. Smart decisions. Dumb mistakes.

Specifically, I hope that the collective experience distilled here will prove helpful to readers who work and revel in visual culture with all its wonderments and perils, who have something to say about the efficacy of images and need visual presentiments to help them say it. It is a story filled with adventure, because the permissions slope is a slippery one, steep and uneven—winding here and there through a sort of Wild West wilderness. In the span of these pages, we will visit great institutions of learning and world-class museums. We will hack our way into the depths of a Manhattan archive and trek the rocky mountain paths above the Sicilian port town of Messina. Great leaps of faith must be taken, often—by you, by owners of intellectual property, by states foreign and domestic. For the subject of intellectual property is itself an intellectual preoccupation and game of the imagination, building on cultural assumptions about ownership, originality, integrity, commodification. So expect to witness all manner of vivid representations, not just visual, but legal too.

Welcome to the Fun House.

2 ✳ An Admission

LET ME BE frank from the outset. This book has a slant. As an occasional writer and a not-for-profit editor charged with publishing the fruits of scholarly research, my circumstances almost invariably align me with the have-nots: academics of modest resources who want to publish visual images in pursuit of an intellectual argument. Arrayed along the other side of what has now unfortunately become a great divide are those who can grant them that privilege: the artists, estates, museums, and picture archives that possess the goods and the legal wherewithal to dictate if and how an image can be used as well as how much it will cost.[1]

The book's mission informs its structure: First come several chapters about the current crisis in our intellectual property system and the multilayered issues that configure it, followed by a nuts-and-bolts primer to help authors navigate the mess. The book finishes with some suggestions for improving the situation, not only for authors but for the creative class overall (and the institutions that support them). While I have never wanted this book to be perceived as an "us against them" kind of tome, the culture of entitlement in which we live makes this all but inevitable. So let me be fair now, if not later: for every outlandish behavior I cite by licensors, I can

1. Rest assured that we publishers watch over the copyright status of our own assets like sentinels ready to flash the bayonet should the slightest infringement provoke.

name innumerable small kindnesses from helpful people who work at licensing agencies and museums.

If I send up repeated distress signals about the behavior of some museums, it's to hold them to a more thoughtful standard than other property owners. Museums are nonprofit publishers too. They know what it means to the health of cultural discourse when property owners indulge in legal overreach and trade on loopholes. I am resorting, of course, to the fiction of the legal person when I talk about museums; if you corner the real people who work in them, you will learn that they are as frustrated about the permissions situation as anyone else. After all, they, too, have to secure permissions to publish images, even for many of the works in their own collections. They have artists, estates, and private collectors to please and appease, and they have to pay fees like the rest of us. Strapped for cash, museums increasingly fret over the financial viability of their publications just as other publishers do.

Still, it is the "museum at large" that is so well placed to influence institutional practice and to stage the reconsideration of the interdependence of public, private, and cultural property, of "goods" and what is good.

In the complex interactions of social freedom and legal restraint, museums occupy a unique position. They operate in the perceived breach between private and public interests and, emerging out of a tradition of historical materialism, are singularly qualified to help craft new ways of thinking about the management of intellectual property in response to a world increasingly preoccupied with this very subject. The capacity of humans to be fair to themselves and to others can never be adequately explained within the close confines of legal language. And the need to consider that fact has never been greater than it is today, for, as Theodor Adorno wrote, "We are forgetting how to give presents."[2]

2. Theodor Adorno, *Minima Moralia: Reflections on a Damaged Life*, trans. E. F. N. Jephcott (London: Verso, 2005), 42.

FIGURE 1. Francis Bacon, *Study after Velázquez's Portrait of Pope Innocent X* (1953). The Bacon Estate asked to read the relevant text for this image and subsequently refused copyright permission to publish it.

3 ∗ *Bleeding Dollars and Euros and Pounds and Yen*

TO BEGIN at the present moment.

"Will there always be art books?" you ask. "Just as there will always be the moon and the stars?"

Ten years ago I would have answered without hesitation "of course." Today I'm not so sure. Between dwindling sales and the soaring costs of acquiring illustrations and the permission to publish them, this segment of the publishing industry has become so severely compromised that the art monograph is now seriously endangered and could very well outpace the silvery minnow in its rush to extinction.

Not to put too fine a point on it, but today's picture is about as pretty as a Francis Bacon painting. With library budgets pared to the bone and the sophistication of the used-book market, sales of specialized art monographs have plunged dramatically over the course of the past several years: books that might have sold fifteen hundred copies ten years ago may now sell only four or five hundred.[1]

You would be right to ask: How can this be? Art history is a discipline that seems reasonably stable. In the United States the field turns out, on average, 220 PhDs a year,[2] and it is one of the few fields with multiple markets for its research. Not only are there sixty-five

1. Textbooks and exhibition catalogs exist in classes apart.

2. An average calculated from the number of annual PhDs awarded between 1996 and 2003. Information provided by the College Art Association (CAA), February 2004.

hundred full-time faculty teaching at four-year colleges and universities in this country,[3] but there are also studio people and curators at museums who constitute sizable markets for scholarly books.

Each year at the College Art Association meeting, I take a few minutes to stroll through the book exhibits, examining what's on offer from other publishers. I wander the aisles slowly, up and down . . . past thousands upon thousands of volumes. I ask myself, Who actually reads all these books? Does *anybody* read them?[4] Certainly, very few people are buying them.

With such grim numbers, why not seek other ways to publish these studies? On the Internet, for example, or as DVDs or digital printouts? Unfortunately, that's not likely to happen anytime soon. While digital storehouses and print-on-demand enterprises can accommodate the tepid demand in many fields, at this point in visual culture it's simply not viable. For one thing, technology has not yet reached the point that we can produce inexpensive digitally based prints with accurate color reproductions. But more difficult to surmount is the ever-worsening problem of obtaining licenses to publish visual material in any medium, let alone a digital one.

Every day we receive alarming reports from the field: ten thousand dollars spent in fees for a narrowly conceived book about illuminated manuscripts . . . twenty, thirty thousand dollars for studies situated in the twentieth century—hideous sums invested in works that will likely sell fewer than a thousand copies. As one author said to me recently about the money she'd had to spend on her first book: "I'd rather have paid cash for a car, thank you very much."

What is most troubling is the raging misapprehension at loose in certain sectors of the art world that just because publications are for sale, ergo, they generate profits.

Many artists, collectors, and museums seem determined to cling to the belief that writers and publishers are getting rich at their expense.

3. Provided by CMG, 2004. CMG is a mailing-list broker. The company was recently acquired by MKTG Service.

4. See Cathy N. Davidson, "Understanding the Economic Burden of Scholarly Publishing," *Chronicle of Higher Education*, October 3, 2003, http://chronicle.com/free/v50/i06/06600701.htm.

They are badly mistaken. Not only are writers and publishers *not* getting rich—they are hemorrhaging dollars and Euros nearly every time a book goes to press.

The irony remains that in this late capitalist culture with its spectacle of images, when the written word seems positively paleographic and the book imperiled, as we turn more and more to the object of vision for information and learning, it is becoming harder and harder and impossibly expensive to include illustrations in books.

Why so expensive?

The answer, put simply, is that nobody has any money anymore. Cultural and educational funding has diminished in the United States and throughout Europe, and we must all rely increasingly on our own schemes and assets to generate the income needed to keep programs running and the doors open. At museums this takes many forms: from the mounting of exhibitions and the loan of important artworks to ever more broadly pitched fund-raising efforts ranging from evening socials and wine tastings to adventure trips up the Nile.

Another income-generating source for museums involves licensing and reproducing images for publication. Depending on the size of the institution and the range of its collection, this can vary from an administrative assistant processing a handful of requests each week to a full-blown rights and permissions department buzzing behind that blue door, headed more often than not by a merchandising expert whose credentials are firmly in retail.

At some financially strapped museums, this income stream is a lifeline; for others, the income may be only modest. But what we find increasingly—as sources of images proliferate and as scholars' tastes broaden to encompass all facets of visual culture—is that this activity is becoming less about the provision of actual images and more about cultivating a brisk trade in the abstract commodity of "permission."

We live in a world of permissions, now more than ever, as the creative and commercial possibilities of the Internet make us increasingly preoccupied with access and control. In fact, the ritual of asking—and granting or withholding—permission has become so deeply embedded in our "cyber psyche" as to put forth a neural

glow and, like a widening gyre, has created large-scale disturbances in what public policy analyst David Bollier calls the "ecosystem of creativity."[5] As another pundit puts it, "Life in our licensed culture has begun to feel natural."[6]

Permissions are hard to avoid, but in principle you don't want to ask permission to publish an image unless you absolutely must. Deciding that you must depends on several factors: the law, yes, but also the extent of its practical application. It further depends on the kind of artwork you wish to reproduce: Is it two- or three-dimensional? A film frame or a photo still? And it depends not least on your publisher's opinions and on the willingness of artists, estates, and institutions to tolerate your antics. The bottom line is that *context is everything*—for the letter of the law will only take you so far, as by now you've surely gleaned.

To ask permission to publish an image or not? That is the question that torments authors. Some editors will urge you to err on the side of caution, to seek every conceivable kind of permission for every little thing. But as anyone who has had to clear permissions knows, caution is not always the safer course. By asking someone for permission to publish an image, you are granting them the right to say no, although what rights owners are more likely to say these days is: "Sure, but it's gonna cost you."

Asking permission when you don't need to can prove extremely awkward later if you go back to a lender to say, "Sorry! Turns out I don't need your silly old permission anyway." Perry Cartwright, rights manager at the University of Chicago Press, compares it to letting the cat out of the bag. Once you do, it's near impossible to shove the squirming beast back in.

Asking permission zealously and unnecessarily also catches you up in a mentality of acquiescence. Acquiescence is a wasting disease rooted in anxiety and ignorance, and it helps propel the all-consuming permissions culture: just as you may feel anxiously compelled to bow to a property owner's extralegal demands, artists

5. David Bollier, "Why We Must Talk about the Information Commons," *Law Library Journal* 96, no. 2 (Spring 2004): 268.

6. Virginia Rutledge, "Fare Use," *Bookforum*, April/May 2005, 33.

sometimes fear (erroneously) that if they ignore even a single attempt to use their work without permission, they may be relinquishing their own claim to it. In the quotidian world of intellectual property, acquiescence operates far beneath the beacon eye of statute or treaty, and capitalizing on it is not good for anyone's health. It wastes time, it wastes money, and it produces a compliant society vulnerable to abuse and wholesale ideological shifts in the law.

So before you start rushing around asking permission for everything, you need to think carefully about your writing project and consider it in light of the legal issues, social principles, and professional practices described here—which is to repeat, you'll want to establish a context for it. Is yours a scholarly effort or a trade book destined for the coffee table? Are you writing in the sciences or in the humanities? Are you publishing an article for which you will receive no remuneration, or are you completing a college textbook that will generate income? When you ask permission, are you reinforcing or undermining the delicate balance of rights between individuals and the broader culture of which they are members?

Without question, the subject of permissions is complicated, and one of the points of this book is to water the issue and make it bloom, thorns and all. If you have read this far, it's likely you are about to join the permissions struggle, if you haven't already. Let's start at the heart of the matter, with copyright.

4 * *What Is Copyright?*

INTELLECTUAL property law is dominated by the concept of copyright. What is copyright exactly, and who invented it?

Copyright is the exclusive, legal right to publish, reproduce, and sell a literary, artistic, dramatic, or musical work. It is designed *primarily* to protect an author or artist[1] against any unauthorized copying of her works[2] *for a reasonable period of time.*

A copyright can be broken down into a cluster of subrights, each of which can be sold or retained at the owner's discretion. For example, a writer or her agent may license one publisher to issue her book in English and another one to publish it in French. A sculptor may allow an art historian to reproduce one of his pieces in a book or a film director to use it in a movie.

Copyright does *not* cover ideas, only their expression. And the expression must be fixed in a tangible medium.[3] For example, just because Salvador Dalí dreamed of melting clocks one night, doesn't

1. Because this book is geared toward the visual arts, I frequently refer to the author as "the artist."

2. Consciously or unconsciously, copyright laws are always tailored to the most up-to-date technologies of mass reproduction; thus, the earliest laws were geared toward books and writing. When new inventions made it feasible to copy pictorial, musical, and graphic works, the law naturally expanded to encompass those media. And today, in the early twenty-first century, we must take into account computer programs, digital technologies, and other kinds of new media too.

3. Thus, skywriting, which is ephemeral, cannot be copyrighted.

mean he holds a monopoly on the idea. What he does—or rather did—possess at one point was the painting he made of the limpid timepieces, and his estate still controls if and when and how and for what purposes that painting may be duplicated—be it in books, on posters, on T-shirts: it's all one and the same under current Spanish law and will stay that way for the eighty years following Dalí's death.[4]

We ought to get one thing straight right now. The proprietary interests of copyright and of free speech are not mutually exclusive. Both rights are granted by the Constitution, and while sometimes their interests seem to clash, over the years a body of case law has been built up about their relationship and what is known as the doctrine of "fair use," which the Supreme Court has demonstrated is what reconciles the two.[5] (How the fair-use doctrine channels free speech into copyright law is taken up in chapter 9.)

Still, the way some people conceive of copyright is as "a kind of giant First Amendment duty-free zone."[6] And on the face of it, copyright is not about free anything. In the United States, at least, copyright is about commerce and spurs to creative enterprise.[7] It grows out of what Mark Rose characterizes as a shift in modern times from "a regime of regulation," whereby the state, for political reasons, controlled the circulation of ideas and printed matter, to a "regime of property."[8]

Modern copyright law originated in England, during the reign of Queen Anne. In 1709 the monarch, "with the advice and consent of Parliament," established a statute recognizing that authors and their

4. Salvador Dalí was a Spanish citizen who died in 1989. Spain's term of copyright protection is now life plus eighty years; thus, Dalí's entire corpus remains in copyright through the end of 2069.

5. *Eldred et al. v. Ashcroft* (01-618), 537 U.S. 186 (2003).

6. Jed Rubenfeld, "The Freedom of Imagination: Copyright's Constitutionality," *Yale Law Journal* 112 (2002), http://www.yale.edu/yalelj/112/RubenfeldWEB.pdf.

7. In many other countries, copyright is viewed as a natural right of the author, placing it on a different plane than U.S. copyright.

8. Mark Rose, *Authors and Owners: The Invention of Copyright* (Cambridge, MA: Harvard University Press, 1993), 15.

publishers should be the primary beneficiaries of the work they produce.[9] The statute granted them the legal right to control whether and how a work should be copied and offered for sale. Equally important, and of great consequence here, the statute also established that such laws should have a *limited* duration, after which a work would pass into the *public domain*, where anyone could copy it and profit from the sale of those copies.[10] The act attempted to balance the needs of writers against those of the public, which are not at all the same, as we shall see. The first term of copyright protection for books already in print was set for twenty-one years, and fourteen years for new works—practically nothing by today's formidable standards—but in setting any term at all, and in recognizing the rights of the author, the Statute of Anne was radical, indeed.[11]

Copyright laws were also enacted in France and Denmark in the eighteenth century. And in the United States, article I, section 8, of the Constitution authorized Congress to create a national copyright system "to promote the Progress of Science and useful Arts, by securing for limited Times[12] to Authors . . . the exclusive Right to their . . . Writings." Most European countries established laws during the nineteenth century to protect the work of their authors.

As the world became a smaller place and as technologies of mass reproduction improved, countries became ever more sensitive to the need to protect authors' rights on an international scale and in different media. Piracy was becoming a big problem. Actually, piracy continues to be a problem.[13] Several years ago when I worked

9. "An Act for the Encouragement of Learning, by Vesting the Copies of Printed Books in the Authors or Purchasers of Such Copies."

10. According to U.S. laws still in effect, artworks *published* before 1923 have passed into the public domain in the United States (much more on this later in the chapter). In most of the European Union and in many other countries, a work passes into the public domain seventy years after an artist dies.

11. According to the statute, if an author were still alive after the initial fourteen-year copyright term, that right was extended for another fourteen years.

12. Note the recurrence of the concept of limited time in copyright language.

13. The Association of American Publishers reports, in 2004, police raids on illegal operations in South Korea, the Philippines, Taiwan, Hong Kong, and Malaysia. AAP, "AAP Pressure on Pirates Intensifies in Series of 2004 Raids," http://www.publishers.org/antipiracy/article.cfm1?AntiPiracyArticleID=4.

in a used-book store, I was routinely offered bootleg copies of such American best sellers as Truman Capote's *In Cold Blood*, issued in Taiwan, in English. American travelers would pick up these counterfeit copies in bookstalls overseas and bring them back to the States. Conversely, I fondly recall one glorious Sunday when I sold $2,300 worth of literary criticism (of all things) to a bespectacled Chinese gentleman with a mild smile who seemed barely able to speak English. My ecstasy at such a sale was surpassed only by that of the other attending clerk, who offered the suggestion that we invest a small percentage of the day's earnings in a celebratory bottle of champagne.

Our glow quickly dimmed, though, when moments later a black squad car pulled up, red light flashing, and we learned that the smiling man was actually the head of a notorious Asian cartel that did a ripping business of converting English texts into various East Asian dialects and selling them on the black market to libraries and scholars. Little had I realized as I helped the old smoothie hoist two heavy suitcases filled with books into the trunk of his car that he had already punched the speed-dial on his cell phone, lining up translators. The FBI had intercepted the call.

That was some years ago. Now most countries have mended their ways—including the United States, whose record is hardly unblemished when it comes to piracy and geopolitics. In America during the nineteenth century, piracy from England was rampant. Publishers, respectable in every other sense, waited at the docks in Boston and New York for the delivery of new British books. There would follow a tremendous scramble to be the first to produce an American edition, which could happen within days or even hours. In the absence of international copyright agreements, the British author very often received nothing.

In 1886 an international convention held in Switzerland established what came to be known as the Berne Union, which guaranteed copyright protection for authors and their works in other countries within the union. A chief purpose was to establish an international mechanism for controlling piracy. For a very long time, the United States refused to join (as did Russia) and, in fact, did not enter into reciprocal agreements with other countries until 1955,

when it finally joined the Universal Copyright Convention (UNESCO 1952), which mandated that each member country treat works by citizens of other member countries as it would those of its own citizens. The Soviet Union became a party to the Berne Convention in 1973, and, finally, in 1988, the United States signed on too.

COPYRIGHT LAW TODAY

So how do you know if a work by an artist is protected by copyright or has entered the public domain?

Unless your research posts you squarely in the mid-nineteenth century or earlier, you are probably dealing with at least some works that are in copyright. Even for many works created in the nineteenth century, you may not be in the clear, for today in most countries copyright terms are linked to the death date of an author. In the European Union and many other countries, the period of copyright protection is the life of the author plus seventy years,[14] a rule that applies regardless of when a work was created or first published (and certainly time enough for more than one generation of heirs to wring every sou they can from the progenitor's original effort).[15] This means that if the artist died less than seventy years ago, you need the permission of his estate to publish any of his work. For example, because Picasso died in 1973, everything he made is still in copyright and controlled by his estate (regardless of who actually owns it), while works by Cézanne, who died in 1906, are now in the public domain.

But there are many, many more works in copyright throughout the world that don't quite fit the European model, and copyright terms and exceptions vary from country to country—and even within a single country: the United States being an exemplar.

14. Except, as noted earlier, in Spain, where the term is the life of the artist plus eighty years, and in France, where military service during the two World Wars has given certain artists a term of life of the artist plus 84 years and 203 days.

15. Except in cases of works published posthumously, to be discussed later in this chapter.

U.S. COPYRIGHT LAW: THE SHIFT FROM PUBLICATION TO CREATION

In the United States, copyright law is pitilessly complicated, and the subject is explored in fascinating detail in a number of weighty tomes, the slimmest being William Strong's *The Copyright Book*.[16]

When it comes to clearing copyright permissions for works by American artists, the law is a maze filled with endless twists and exceptions. This is because works created before 1978 are protected by a different copyright standard than those created since 1978.

Art Created Before 1978—the Publication Standard

The law pertaining to copyright in the United States is like no other in the world. From our nation's inception until 1978, the copyright status of a work was tied to if and when it had ever been *published*, not to when it was created or to when its maker died, as holds throughout much of the rest of the world. And even though U.S. law has evolved considerably over the years, it has not entirely shaken off the old standard.

How did we ever come to adopt such a system? To comprehend what happened, we must keep in mind that the incentives of copyright in the United States have always been more deeply rooted in the growth of commerce than in the moral right of the author; thus, a work of intellectual production has little intrinsic value until it assumes a form that allows it to circulate through a marketplace.

When the United States was a young frontier nation, a loose federation of states with an expanding western boundary, unpublished works of creative expression were considered simple private property, in the same category as a mule or the family Bible. Then, as now, there were physical property rights in objects—such as a manuscript or a painting—and there were also intangible intellectual rights for materials that hadn't been published. All of these

16. William S. Strong, *The Copyright Book*, 5th ed. (Cambridge, MA: MIT Press, 1999).

rights were covered by the common law of the state in which their author resided. Most state laws protected personal property against misappropriation in *perpetuity*. As long as Aunt Hazel's watercolor, painted on the eve of the Civil War, continued to hang over the wing chair in her parlor, it existed in a sleepy state of embryosis. The watercolor would not be "in federal copyright" until it was actually reproduced—hatched, if you will—for public dissemination. At that moment, the copyright clock would start to tick; the term limitation would set in. Aunt Hazel's painting was no longer simple private property. Now it was part of the broader culture, destined to enter the public domain, so it was governed by federal—statutory—law.

For many years, this system made rather good sense. Copyright arose in a century when text was the chief medium for transmitting information, movable type dominated publishing technology, literacy had increased, and the explosion of newspapers and books reinforced the certitude that ours was a text-driven society. Professional writers and their publishers understood the rules that prevailed, because they produced expressly for a market audience. The framers of the Constitution built this writers' bias into the copyright and patent protection clause ("to promote the Progress of Science and useful Arts, by securing for limited Times[17] to *Authors* and Inventors the exclusive Right to their respective *Writings* and Discoveries" [emphasis mine]).

Copyright law is always struggling to catch up with the newest technologies of reproduction and information transmission. The invention of any new medium forces us to revisit how we think of copyright and the protection we afford creative property. Virtually the moment the U.S. Constitution was ratified, Congress decided to enlarge the scope of copyright protection to embrace the "author or authors of any map, chart, book or books."[18] And in 1831 the law was amended to clarify protections for musical compositions and various kinds of prints and engravings. Within just a few more years, Congress was working yet again to expand the range of me-

17. Federal protection has limits because it is constitutionally based, but state (common) law usually did not, which is why copyrights were often viewed as perpetual (until 1978).

18. Copyright Act of 1790, 1 Stat. 124, 1.

dia and objects encompassed by copyright law, and throughout the nineteenth century, courts sought to discover how, and if, various technologies—including photography—reflect the intrinsic values of writing.[19]

But as the twentieth century drew near, bringing with it enormous advances in technology, the law—meticulously redacted to keep pace with the life cycles of text—seemed less able to cope with the publishing needs of the visual arts. Suddenly paintings and statues could be published in reasonably accurate likenesses in reviews and journals, thanks to negative-based photography and the perfection of chromolithography.[20] Since then, fueled by mass media as well as German determination to found an academic discipline around the study of art, most of the art we view is not really art at all but a strange, luminous image of art reconstituted in a surrogate medium. These surrogates, projected on a screen or inked on paper, serve to *document* something entirely other than themselves, whereas in literary culture, print has forever been construed as a direct embodiment of text (an important distinction to which we'll return).

Copyright law has always been difficult to parse for traditional object-based media, but how are we think about contemporary practices? Each artist works within a particular realm of intellectual possibilities defined by the culture and technology of the moment. There was the great artistic watershed of the fifteenth century joined in part to the invention of oil painting, followed by other breakthroughs connected to photography, moving pictures, and more recently digital imaging. The day that Marcel Duchamp arranged for a porcelain urinal to be delivered to the 1917 Independents exhibition in New York City was the day that a number of closely held beliefs about what art is began to shift. No longer was the object expected to demonstrate an artist's facility at drawing or

19. For example, in the 1884 Supreme Court case *Burrow-Giles Lithographic Co. v. Sarony*, the Court held that photographs were "writings" within the sense of the copyright clause of the U.S. Constitution. We will consider the copyright status of different kinds of photography in chapter 5.

20. However, paintings, sculpture, and drawings could be *interpreted* through engravings and other kinds of graphic arts, considered original works in their own right and therefore copyrightable.

painting or modeling; nor did it need to evince a value of *singularity* to be credible. It didn't even have to originate with the artist who claimed it. The thing was art if the artist said it was.

Today, in the new millennium, what are we to make of art that is virtual, not actual? Or art driven by social participation? How do we determine what a medium is anymore or think about how to "fix" a work of artistic expression intended to be ephemeral? And what about the exercise of a deliberate, critical aesthetic based on the appropriation or redress of other artists' work?[21] More than ever, art offers a host of self-conscious challenges to the concept of authorship. What I am driving at is that in the United States visual artistic property was, and to a degree still is, caught in a thicket of inadequate legal discourse that is inherently biased toward text and not images. This fundamental institutional bias, which permeates all copyright law, deserves our attention because different media are fostering somewhat different practices and concerns as to how the law is applied.

The Copyright Act of 1909

In 1909 a new federal copyright law was instituted that added further layers of complexity to what had become over time a tangled, bloated mess of common, state, and statutory laws. Though the ostensible purpose of the law was to offer more federal—and therefore consistent—protection to intellectual work, the effect turned out to be quite the opposite: among other things, the 1909 Copyright Act announced that published works needed to be registered with the U.S. Copyright Office[22] and that works issued without a proper copyright notice[23] entered the public domain the moment

21. Readers may find of interest Martha Buskirk's *The Contingent Object of Contemporary Art* (Cambridge, MA: MIT Press, 2003), which discusses the tectonic cultural shifts in art and authorship since the 1960s.

22. Most unpublished works continued to be protected by state laws. The 1909 Copyright Act did offer some very limited categories for registration of unpublished works—such as speeches, works in final form not meant to be exploited by typesetting and publication.

23. The most common form of copyright notice is the symbol © followed by the name of the copyright owner. There were and are other acceptable forms, which can be viewed at the website of the U.S. Copyright Office, http://www.copyright.gov.

they were published! The law also spelled out an intricate process whereby copyrights could be renewed. Under this system, one had to be extremely diligent to keep one's work out of the public domain. And congruent with copyright culture's deep-seated textual bias, there existed no category for registering works of visual art. We have been dealing with the repercussions of this addled piece of legislation ever since.

Art Created In or After 1978

Fallout from the 1909 Copyright Act, coupled with a desire to bring U.S. law into line with the rest of the world, ultimately drove Congress to seek relief in the form of a new streamlined copyright law, which took effect in 1978. The new law was to address the technical and social realities of the twentieth century. As technologies of duplication, shipping, and transmission evolved to the point that works could be disseminated throughout the world at lightning speed and in modes other than traditional publishing,[24] it became imperative for the United States to establish a common value for all intellectual property from the moment it was *created*. From the standpoint of the visual arts, this was far and away the most important and well-considered change in the intellectual property law of this country, when we moved from a *publication* standard to one of *creation*. Starting in 1978, any new work would be protected from the moment it took fixed form, and the term would endure for "the life

24. Via Xerox and fax, incipient computer transfer and air courier. For example, the invention of the Xerox machine proved the leaven for course packs, with cheap, mechanically produced copies of texts and images suddenly available. Xerography was invented by Chester Carlson in 1937, but it took two more decades (in 1959) before the Haloid Company, known today as the Xerox Corporation, introduced an office copier, the Haloid Xerox 914, to the business market, making it possible to produce cheap copies on paper quickly and endlessly. Practically overnight the number of office copies soared from 20 million in 1955 to 9.5 billion in 1964. Today copies number in the trillions, to say nothing of the probably billions of digital copies made each day. See David Owen, *Copies in Seconds: How a Lone Inventor and an Unknown Company Created the Biggest Communication Breakthrough Since Gutenberg—Chester Carlson and the Birth of the Xerox Machine* (New York: Simon & Schuster, 2004).

of the author and fifty years after the author's death."[25] That term
has since been extended to seventy years.[26]

The new standard simplified matters for work created since 1978.
It also eliminated the devilish copyright renewal mechanism. And it
established a timeline for *all* work—published or unpublished, reg-
istered or not—to eventually enter the public domain. No longer
would unpublished works created before 1978 be protected in per-
petuity, but only for the artist's lifetime plus seventy years or un-
til the end of 2002, whichever proved longer. This means that Aunt
Hazel's antebellum-era watercolor—still unpublished and hanging
on a rusty nail above the old wing chair now occupied by her elderly
great-great-nephew—is today, *finally*, in the public domain. In fact,
as 2002 lapsed into 2003, untold numbers of works predating the
twentieth century went into the public domain.[27] Conversely, many
others were published that same year in order to bestow upon them
statutory copyright protection. Yes, 2002 was all critical—the last
whistle stop if you were going to prevent older property from enter-
ing the public domain. In 2002 it was now or never.

An interesting case centers on the photographs of Charles Dodg-
son—aka Lewis Carroll—who, you'll remember, made all those
pictures of little girls between 1855 and 1880. Dodgson was an En-
glish citizen who died in 1898. According to British law, the vintage
photographs he made are now in the public domain. However, it
was not by coincidence that in 2002 in the United States, taking
advantage of the 1976 Copyright Act, there appeared two substan-
tial volumes of Dodgson's photographs, both of them published by
American presses: *Lewis Carroll, Photographer: The Princeton Univer-
sity Library Albums* and *Dreaming in Pictures: The Photography of Lewis*

25. U.S. Code, Title 17—Copyrights, chap. 3, sec. 302(a), http://uscode.house.gov/
download/pls/17c3.txt.

26. In 1998 Congress approved the extension by passing the Sonny Bono Copy-
right Term Extension Act.

27. Like many works, Aunt Hazel's watercolor entered the public domain on Jan-
uary 1, 2003. Let's say Aunt Hazel died in 1864, and the work has remained in the
possession of her heirs ever since. If we add seventy years to Aunt Hazel's death
date, that is 1864 + 70 = 1934. The year 2002 is the greater of the two dates, allow-
ing for the longer term.

Carroll,[28] the latter a catalog for a traveling exhibition (limited to American venues) of Dodgson's photographs. Many of these photographs had never been published before. The 1976 Copyright Act allowed one great big loophole for older intellectual property to qualify for copyright: any work created before 1978 and published between 1978 and the end of 2002 would be protected for the author's life plus seventy years *or* to the end of 2047, whichever is greater. In 2002, therefore, the executors of Charles Dodgson moved to publish as many of Dodgson's photographs as possible. With the clock ticking, the Princeton albums were published, and—voilà—dozens if not hundreds of photographs were hauled back from the brink of the public domain. Today their intellectual property component remains in the firm grasp of Dodgson's executors, at least within the United States. Thus, the 1976 Copyright Act afforded Dodgson's "executors" an exclusive opportunity to capitalize on the fruits of the famous logician's labor for at least another forty-five years, until almost a century and a half after his death.[29]

Something else the 1976 Copyright Act did *not* do was eliminate all the hairsplitting over the status of works *published before 1978*. It still mattered if those works had been published or registered with the Copyright Office and if so, when. As is customary, Congress chose to follow the general principle that new laws are not retroactive. So there you have it. We are stuck with vestiges of the dual and dueling system, at least for now.[30]

28. Roger Taylor and Edward Wakeling, *Lewis Carroll, Photographer: The Princeton University Library Albums* (Princeton, NJ: Princeton University Press, 2002); Douglas R. Nickel, *Dreaming in Pictures: The Photography of Lewis Carroll* (San Francisco: San Francisco Museum of Modern Art and Yale University Press, 2002).

29. Some of the works had been published before 1923 or had been published in the tumultuous copyright years in the mid-twentieth century but had gone into the public domain for various reasons we've discussed: copyrights were not renewed, etc. The two volumes each contain the interesting copyright notice: "Photographs by Lewis Carroll not in the public domain are © 2002 The Executors of the Estate of C. L. Dodgson." Such a vague notice, without identifying specific photographs, permits the volumes to be sold into different countries.

30. It took even longer, another thirteen years, for Congress to eliminate the requirement that works be published with a copyright notice to remain out of the public domain. Apparently, they thought that retaining this requirement would actually accelerate entry into the public domain.

FIGURE 2. Willem de Kooning, *Untitled V* (1982). Oil on canvas, 6' 8" × 70". Gift of Philip Johnson. The Museum of Modern Art, New York, NY, U.S.A. © 2006 The Willem de Kooning Foundation/Artists Rights Society (ARS), New York. Digital image © The Museum of Modern Art/Licensed by SCALA/Art Resource, NY. What have we here? Why has ARS affixed a 2006 copyright registration mark to a work painted in 1982 and published several times before now? Is this a stratagem to prolong the term of copyright? Note also MoMA's copyright claim to the reproduction image. We will discuss this particular kind of legal assertion in chapter 5. Image provided as a JPEG file. Fees paid: copyright for the De Kooning painting to the De Kooning Foundation/ARS, $45; use and alleged copyright for the digital file to MoMA/Art Resource, $30.

Consider Willem de Kooning, who died in 1997. Under the new law, a painting he made in 1982 (fig. 2)—that is, after 1978—is protected by copyright until 2067: (1997 + 70 = 2067).

On the other hand, an earlier de Kooning sculpture (fig. 3) created in 1973 and *first published* in an exhibition catalog in 1974[31] is protected under the *old* law until 2069 (1974 + 95 = 2069)—two years

31. Philip Larson and Peter Schjeldahl, *De Kooning Drawings/Sculptures* (New York: E. P. Dutton, 1974), a catalog for an exhibition organized by the Walker Art Center.

FIGURE 3. Willem de Kooning, *Bar Girl* (1973). © 2006 The Willem de Kooning Foundation/Artists Rights Society (ARS), New York. Photograph by Hans Namuth. Courtesy of the Center for Creative Photography (CCP), University of Arizona. © 1991 Hans Namuth Estate. This image involves two different copyrights. Copyright to the sculpture in the photograph is controlled by the Willem de Kooning Foundation (note again, the curious 2006 copyright notice provided by ARS). The photograph itself was made by the photojournalist Hans Namuth, who died in 1990. Note that the copyright shifted to his estate the following year. Namuth's work is now managed by the Center for Creative Photography. Museums and other nonprofit institutions increasingly serve as second-generation executors and copyright clearance centers for artists' estates. The Metropolitan Museum of Art, for example, controls the Walker Evans Archive, and the Seattle Art Museum manages the estate of Mark Tobey. Image provided as a JPEG file by CCP. Fees paid: copyright for the De Kooning sculpture to the De Kooning Foundation/ARS, $45; copyright for the Namuth photograph, $150; CCP charged an additional use fee of $55 for the image.

longer than the later work!—demonstrating why it is pointless to apply logic to U.S. copyright law and why a practical view is essential when it comes to evaluating the copyright status of artworks. I don't know about you, but I'll have expired a long time before either of those copyrights do, and trying to master the minutiae of two systems is, for most people, like trying to herd cats. It's agony, and there's usually no need. In the final analysis, all you, as an author, need to care about is whether the work you want to publish is in copyright or in the public domain *now*, when you need it. Does it

really matter when the copyright expires unless it's tomorrow? So, to drill through all the legal cheese, a chart that assembles the most relevant information about when works by U.S. artists enter the public domain is given below (courtesy of Lolly Gasaway).

In a nutshell, when it comes to the work of U.S. artists:

- Anything *created* since 1978 is in copyright now.
- *Unpublished* artwork created before 1978 remains in copyright for the life of the author plus seventy years, except that
- *Unpublished* artwork by an *author who died before 1932* entered the public domain no later than 2002.
- Anything published *before* 1923 is in the public domain.
- *Many* works *published* between 1923 and today are in copyright now.

A hard nut, granted, yet nothing that a large sledgehammer and Gasaway's chart won't help you crack. But here's the rub: How do you know if a particular artwork has ever been published? This is a question that has exercised editors and authors for years. While the copyright registration and notification system has succeeded with some consistency for *texts,* it has been hit-or-miss when applied to the visual arts. Few artists have ever registered paintings, sculptures, prints, or photos with the U.S. Copyright Office, and until very recently there existed no consistent mechanism for doing so. It is, therefore, impossible to determine reliably what artwork was or wasn't published before 1978.

Here is where the hinterland of copyright begins; you are standing at its brambled edge, looking out over a failed system of broken grids and trending byways that wander away from their source, intersect, circle endlessly, or dead-end, for even though the law prescribes that any work by a U.S. artist that was *published* before 1923 is now in the public domain, you will find that most artists and estates take the view that a work is in copyright for the life of the artist plus seventy years, especially when it is to their advantage to do so. The estate of Georgia O'Keeffe will gladly charge you a fee if you wish to publish her *Series I, No. 7,* even though the painting

Date of Work	Protected From	Term
Created 1-1-78 or after	When work is fixed in tangible medium of expression	Life + 70 years[1] (or if work of corporate authorship, the shorter of 95 years from publication, or 120 years from creation)[2]
Published before 1923	In public domain	None
Published from 1923–63	When published with notice[3]	28 years + could be renewed for 47 years, now extended by 20 years for a total renewal of 67 years; if not so renewed, now in public domain
Published from 1964–77	When published with notice	28 years for first term; now automatic extension of 67 years for second term
Created before 1-1-78 but not published	1-1-78, the effective date of the 1976 Act, which eliminated common law copyright	Life + 70 years or 12-31-2002, whichever is greater
Created before 1-1-78 but published between then and 12-31-2002	1-1-78, the effective date of the 1976 Act, which eliminated common law copyright	Life + 70 years or 12-31-2047, whichever is greater

Source: Lolly Gasaway, University of North Carolina, http://www.unc.edu/~unclng/public-d.htm.

1. Term of joint works is measured by life of the longest-lived author.

2. Works for hire, anonymous and pseudonymous works also have this term. 17 U.S.C. § 302(c).

3. Under the 1909 Act, works published without notice went into the public domain upon publication. Works published without notice between 1-1-78 and 3-1-89, effective date of the Berne Convention Implementation Act, retained copyright only if efforts to correct the accidental omission of notice were made within five years, such as by placing notice on unsold copies. 17 U.S.C. § 405. (Notes courtesy of Professor Tom Field, Franklin Pierce Law Center, and Lolly Gasaway.)

was published in 1922 in *Vanity Fair* magazine, placing it in the public domain.

I did, as a matter of fact in preparing this book, write O'Keeffe's agent to request permission to publish four of her paintings created between 1919 and 1921.[32] Of the four works, two had been published in magazines prior to 1923, putting them squarely in the public domain. Though I did not mention their publication history in my query (to test if the agent kept track of such things), I did furnish the entry number for each work as it is listed in Barbara Buhler Lynes's *Georgia O'Keeffe: Catalogue Raisonné*. Each catalog entry tells where and when a work was first published, so I figured I had done the appropriate sign posting. Within a few days I received a cordial e-mail back from the agent quoting a copyright fee for each work—nary a word that two of the images were in the public domain. Why not? All I can surmise is that

- The agent didn't have the information to make this assessment;
- The agent had the information but ignored it because I actually *asked* for permission, which she may have taken as a grant to provide it;[33] or
- She was representing the licensing terms of O'Keeffe's executors, who may have ignored or not been aware of the applicable federal law in setting their policies.

A PRACTICAL VIEW

To illustrate just how different the law is in the United States and in Europe, let's consider once again Picasso, who, remember, died in

32. E-mail from author, sent July 21, 2004. The four works for which permission was requested were *Series I, No. 7* (1919), oil on canvas, Milwaukee Art Museum (#279 in Barbara Buhler Lynes, *Georgia O'Keeffe: Catalogue Raisonné* [New Haven, CT: Yale University Press, 1999]; reproduced in *Vanity Fair*, October 1922; public domain); *Apple Family I* (1920), private collection (#316 in Lynes, *Catalogue Raisonné*; reproduced in *Vanity Fair*, July 1922; public domain); *Alligator Pears* (1920–21), Georgia O'Keeffe Foundation (#338 in Lynes, *Catalogue Raisonné*; still in copyright); and *Blue and Green Music* (1921), Art Institute of Chicago (#344 in Lynes, *Catalogue Raisonné*; reproduced in *Vogue*, October 1923; still in copyright).

33. Note the conjuring power of acquiescence.

1973. In 1904 at the age of twenty-three, Picasso published an etching titled *The Frugal Repast*. Is that particular work in copyright? In France and the rest of Europe, it is; however, according to U.S. law, because the work was published prior to 1923, it is technically in the public domain *within the United States and its territories*.[34] Now, that's fine in principle, and if you happen to be writing a book about Picasso that will *only* be distributed in the United States, you won't need copyright clearance to publish that etching. But because it's now possible to sell almost any book anywhere on the planet, your publisher will want you to clear copyright permissions accordingly. Thus, for all practical intent, in this instance the "life plus seventy" rule must prevail.

By way of counterexample, a work of a U.S. artist published before 1923 is in the public domain worldwide. No country is obligated to protect a foreign artist's work beyond the copyright term of the artist's own country, though some do.

THE PUSHMAN PRESUMPTION

Many collectors think that they own the copyright to works in their collection and that they can license them for publication. More often than not, they think wrong. In the real world, possession may be nine-tenths of the law, but not in the world of intellectual property. Just because you own a Jasper Johns *Bull's Eye*, doesn't mean you get to decide if it's published. That's up to Mr. Johns.

The copyright to a work has for many years been viewed as distinct from its physical embodiment. It has taken awhile for this distinction to be thoroughly worked into the laws of the United States (though the progression has always been toward a separation of physical and intellectual property). Thus, it was sometimes construed that "if an artist parted with the only thing from which copies [of an artwork] could be made, he or she had in effect given up the right to copy it."[35] One would assume that the law would have

34. Regarding authors and artists who are citizens of other countries, we are not obligated to protect them longer than we do our own citizens.

35. Thanks to William Strong for discussing this historical point with me.

evolved rather rapidly as advances in technology gave an artist more tangible control, and hence authority, over the work he produced, but in fact it wasn't until the 1940s that this matter came to a head in the art world. In 1942 a New York state case titled *Pushman v. New York Graphic Society* involved a decision that seemed to reinforce the fading view that the copyright to an artwork was automatically conveyed to the buyer of an artwork *unless* the artist arranged to retain it through a written agreement, such as an explicit condition in the bill of sale. Collectors continued to cling tenaciously to the "Pushman presumption" in claiming copyright to works even after the distinction between the material work and its copyright had been made explicit in a 1947 addition to the 1909 Copyright Act:

> The copyright is distinct from the property in the material object copyrighted, and the sale or conveyance, by gift or otherwise, of the material object shall not in itself constitute a transfer of the copyright, nor shall the assignment of the copyright constitute a transfer of the title to the material object.[36]

In 1966 *Pushman* was fully discredited by the New York State legislature because it was so unfair. And in the federal 1976 Copyright Act, section 202, Congress made it crystal clear that if you are going to transfer copyright in a work, you must do so in writing.

Today in the United States, as in most of the world, Picasso's *Les demoiselles d'Avignon* is considered property in two senses: the copyright belongs to the Picasso heirs (or "the Administration," as they prefer to be called), the physical painting to the Museum of Modern Art. Each is separate. The Picasso Administration cannot recall the painting any more than MoMA can decide how or when it is to be published.

The legal gap between the ownership of a painting and of its copyright sometimes leads to intriguing situations. The entire oeuvre of

36. Section 27 of the 1909 Copyright Act (July 30, 1947, c. 391, 61 Stat. 660). This language remained in force until succeeded by section 202 of the 1976 Copyright Act (effective January 1, 1978), which is equally unequivocal: "Ownership of a copyright, or of any of the exclusive rights under a copyright, is distinct from ownership of any material object in which the work is embodied. Transfer of ownership of any material object, including the copy or phonorecord in which the work is first

the painter Edward Hopper, who died in 1967,[37] entered a state of legal limbo through an odd sequence of oversights. The sole beneficiary of Hopper's estate was his wife, Jo, who died a year after he did. She left all the works she still possessed to the Whitney Museum, but it seems she may have neglected to designate an heir for the intellectual property component of her husband's production, and there were no hereditary heirs. Even though specific pieces went to the Whitney Museum, it is not clear that the associated copyrights transferred with them. Without a de facto estate, a great many of Hopper's works are now treated as if they are in the public domain.[38]

COPYRIGHT'S FUTURE

That's the state of things right now. But laws are meant to be amended, as they say. After all, intellectual property is a thriving industry, and copyright laws exist to encourage industry . . . or industriousness—at least they used to. Alas, in some respects, this inducement is waning, given the extravagant length of present terms. In the early years of copyright, the virtues of short terms were inestimable. Lasting only twenty years or so, they supported culture building on two levels. First, they offered incentive: to fully reap the benefits predicated on copyright, a person had to keep working. One could not simply write a best seller and then expect

fixed, does not of itself convey any right in the copyrighted work embodied in the object; nor, in the absence of an agreement, does transfer of ownership of a copyright or of any exclusive rights under a copyright convey property rights in any material object."

37. After *Pushman*'s demise.

38. The Whitney Museum has recently taken the position that they possess the copyright to the works in the Josephine N. Hopper Bequest. Note to author from Anita Duquette, Whitney Museum, summarizing the position of the museum's legal counsel, September 13, 2005. "The Whitney Museum's position is that the Museum holds the copyright to the Hopper works (Edward Hopper and Josephine N. Hopper) in our collection. We believe that under the law that applied at the time of the Josephine N. Hopper Bequest, the Bequest transferred the copyrights along with the physical works. The Josephine N. Hopper Bequest is comprised of over 2,500 works by Edward Hopper and hundreds of works by Josephine N. Hopper."

to kick back and retire on the residuals. To prosper, one had to keep producing (a principle that still invigorates patent law).[39] Second— and with apologies to Darwin—once a work enters the public domain, how a culture self-selects is telling. Why does there continue to be sufficient demand for a book to keep it in print? What makes a particular painting so meaningful as to command valuable display space in a gallery? Which works are vetted for disposal in the public mind over many years gives shape to a society's future and allows us to track its values.

For the record, I'm all for copyright protection, but I'm also for shorter shelf lives. Certainly, I'd never deny a bit of cash to a living artist; however, once the epitaph of Oh Great One has flaked away from the tombstone and the immediate family are but dust as well, and the interested party is now a third cousin twice removed or some other vestigial relation, or—worse—a coven of professional "executors" aided and abetted by powerful rights agencies, then we've entered a very quaint zone of presumed entitlement that can be, well, deeply infelicitous for the working scholar.

It's not easy, I am told, to be the one charged with managing the legacy of a great artist. That's no doubt true. But how difficult it is, too, to be someone trying to write responsibly about that artist and having to jump through endless tiny hoops of fire to do it.

Still, it doesn't matter what I think. In today's global village, we cannot fix the limit of copyright expansion except by overturning an entire value system. And while rights holders take no end of pleasure in remarking upon their concern to preserve the "integrity of the images" they control, these are effects after the fact that copyright law exists to serve the world of hard currency and commerce.

39. The terms of protection for patented products are far shorter than those for copyrighted works. In most countries they are between sixteen and twenty years, with shorter patent lives for pharmaceutical and medical products. One of the purposes of the short term is to prevent monopolies. For example, in the United States pharmaceutical patents now expire after thirteen to sixteen years (not so long ago, the term was eight years), allowing the benefits of a drug to be widely enjoyed at a reasonable cost. The net result is that inventors are encouraged to produce new work often.

A judge will typically evaluate an infringement case by subjecting it to a certain test: does a situation exist that denies the owner of a protected work an opportunity to profit *financially* from the copying of it?

By comparison, when the economic imperative recedes and "higher goods," so to speak, are involved, the *giving or sharing* of a copy to educate—that is, without a thought to profit—then the law's complexion begins to blur. And for this reason, copyright standards are being challenged all the time. Right now we are in the midst of an enormous groundswell to reorganize the limits of copyright. Today's news is alive with stories of BitTorrent, LiveWire, and other Internet companies who have offered published-music downloads to individuals on a free-for-the-taking basis,[40] but an equally important theater of war is the book, where a high-stakes battle is being waged between university libraries and publishers. The most potent weapon in the challengers' arsenal is the factor known as "fair use" (to be discussed in detail later). At the same time, content providers are moving to rarefy even the simplest and least original information by declaring it to be protected[41] by copyright: as digital technology advances with great rapidity and offset printing is displaced by print-on-demand initiatives, and as libraries and schools are acquiring publications in electronic form, all eyes have turned their beady gleam to copyright and profiteering in the new medium.

Turn the page.

40. An enterprise that was countered in 1998 by the passage of the Digital Millennium Copyright Act (DMCA). The act is "designed to facilitate the robust development and worldwide expansion of electronic commerce, communication, research, development, and education in the digital age" (Senate Rpt. 105-190). At the same time, it spells out rules of copyright in the digital environment. See the following U.S. Copyright Office web page: http://www.copyright.gov/legislation/dmca.pdf.

41. On the international level, see chapter 5, n. 23.

FIGURE 4. Frans Hals, *The Laughing Cavalier* (1624). Oil on canvas, 83 × 67 cm. The Wallace Collection, London.

FIGURE 5. Leonardo da Vinci, *Mona Lisa* (c. 1503–1506). Oil on wood, 77 × 53 cm. The Louvre, Paris. Both of these works are firmly ensconced in the public domain. Digital images (JPEGS) for figures 4 and 5 were obtained via the Art Renewal Center website: www.artrenewal.org. Fee paid: $0.

5 ❊ *The Copy Trade and the Public Domain*

> ... and I thought how unpleasant it is to be locked out;
> and I thought how it is worse perhaps to be locked in. ...
>
> VIRGINIA WOOLF, *A Room of One's Own*

THERE IS A land called the public domain, a commodious domicile for intellectual property that is no longer protected by copyright. Anything in the public domain is yours to publish to your heart's content, and, from the standpoint of copyright, you don't need anyone's consent to do it. Either the term of protection has expired or the work may never have been in copyright in the first place.

All sorts of things are in the public domain: the oeuvre of Eugène Delacroix, for example, because the French painter has been dead for more than seventy years and no longer has an active estate; certainly the *Mona Lisa*, whose creator lived five hundred years ago, long before copyright was invented.

That there exists a public domain is universally acknowledged, though, as we've seen, countries may differ on when cultural property enters it. A common principle used to hold that once something was released into the public domain, it could not be taken back; however, in the past thirty years or so, restorations of copyright have become almost habitual. Premised on alleged injustices in earlier copyright laws, such moves are very often prompted, in America at least, by efforts to appease powerful content providers.[1]

1. In the United States, a restoration occurred when the Copyright Act was revised in 1976 (and took effect in 1978). This is why some works made in the mid-twentieth century have a copyright term of ninety-five years. Another limited restoration was enacted for foreign works that had been in the public domain in the United States prior to 1996 and whose copyright was restored under the

Not only can we no longer be assured that just because something enters the public domain it won't pop back out, but the whole Enlightenment idea of a public domain is also becoming obsolete. While nobody owns the public domain per se, there is nonetheless a struggle intensifying over who among us actually controls it. This is more than a pleasing tension between two intelligent points of view. Everywhere roadblocks are being erected, the domain walled off behind a barrier of secondary ownership and noncreative entitlements. In the art world, many who own public-domain objects are working to change the basis of copyright protection altogether by asserting coverage for precise photographic copies of materials in their collections and forcing others to assert that claim for them (usually in a published caption or credits section) in exchange for permission to publish. In a series of smart moves related to the public domain, they are locking it down. The public domain may soon be the legal equivalent of delectable candy behind a counter where authors may look but not partake. At the rate of current enclosures, without permission to publish those gorgeous images, soon all one will be able to do is blunt one's nose against the glass and stare.

At stake is the very definition of intellectual property, which, since the Statute of Anne, has been rooted in the concept of originality.

ORIGINALITY

The year 1936 saw both the rapid ascent of fascism in Germany and the publication of Walter Benjamin's benchmark essay "The Work of Art in the Age of Mechanical Reproduction," which the philosopher had written in response to the triumph of National Socialism and as a critique of the ideological power of the aesthetic employed for political ends. Benjamin posits that as new and more technologies of mass reproduction have altered modes of perception through

Uruguay Round Agreements Act (URAA). See Circular 38b, "Highlights of Copyright Amendments Contained in the Uruguay Round Agreements Act (URAA)," http://www.copyright.gov/circs/circ38b.pdf, for further information.

the proliferation of copies of artworks (in books, newspapers, magazines, advertisements, film) and have detached those works from their usual contexts, "that which withers in the age of mechanical reproduction is the aura of the [original] work of art."[2]

But, with all due respect to Benjamin, does mass duplication really serve to impoverish art, and, if so, at what point might an image be rendered worthless? Does it matter how the image is used? Consider how many times you've viewed an image of the *Mona Lisa* immured in the fob of a key chain or impressed upon a tea tray, and then go purchase a ticket to the Louvre. To enter is to find yourself restrained by spectacular displays of power: high-voltage alarm systems, security cameras and metal detectors, X-ray machines and warning signs, plush velvet ropes, blinking laser beams, guards in mock-military garb—all of which only perpetuate the cult of the original and enhance its value and the museum as its anointed temple. All those copies circulating though our culture don't seem to have diminished the painting a bit.

At the same time, there is a growing presumption once more in certain sectors of the art world that if one possesses an *original* work, one ought to also control its copies, even for works in the public domain. As a result, collectors are constantly contriving strategies to exert control over the publication of these images. The most obvious way is by limiting access to the works themselves.

You want to photograph the *Mona Lisa?* Good luck. For one, the Louvre forbids it, and even if you could photograph her, those dense crowds huddled around Leonardo's masterpiece are just as impenetrable as ever,[3] and the lady, her expression fixed in oils, has repaired

2. Walter Benjamin, "The Work of Art in the Age of Mechanical Reproduction," in *Illuminations: Essays and Reflections*, ed. Hannah Arendt, trans. Harry Zohn (New York: Schocken Books, 1969), 221. Thanks to historian Michael Steinberg for sharing his expertise on Benjamin's introduction to the essay.

3. Benjamin might view this as an instance of "the distracted mass [absorbing] the work of art." Benjamin, "The Work of Art," 239. On the other hand, as Hillel Schwartz says, "Only in a culture of the copy do we assign such motive force to the original." *The Culture of the Copy: Striking Likenesses, Unreasonable Facsimiles* (New York: Zone Books, 1996), 141.

even farther from the audience to gaze out with a kind of mocking self-importance from behind a pane of bullet-proof glass in an ionized sepulcher. How does one photograph that?[4]

Some museums allow photography in their galleries. Many do not. Most prohibit the use of tripods, and hardly any will allow you to use a flash mechanism, which their underwriters fear can damage fragile works of art or possibly explode and injure other visitors. More than anything, museums want you to purchase or rent reproduction photographs from them.

One might say it is the best of times, the worst of times. Twenty years ago slides, photographic prints, transparencies—copies all—were a dime a bunch. Now they are precious commodities if you have the wherewithal to exploit them. You see, for all Benjamin's acuity, he hadn't reckoned on the explosion of restrictive covenants that exist today and the fact that duplicate images have become major capital assets in their own right and objects of enormous contention. Never before has the mechanically—or digitally—produced copy been such a fungible good.[5] Apart from the imprint of an image on your own brain, you are *not* free anymore to do as you please with duplicate images you may buy, borrow, or even make yourself. There's often a hitch. In fact, there's almost always a hitch, and with the recent extensions of copyright terms and all the "extralegal" trappings linked to claims of legal entitlements (which we'll attend to shortly), they are growing more worrisome by the minute.

THE PRIVATIZATION OF THE PUBLIC DOMAIN

American legal history is a big sticky glob of competing traditions and interests. At the root of most modern law, though, is the presumption of a utilitarian commitment to the common good. Laws, even stupid ones, are so enacted in our society. The public domain

4. A new "anti-terrorist" vitrine has been designed for her by the Italian firm Goppion to protect against "every conceivable type of threat: humidity, heat, light, theft, vandalism—even terrorism." "New Anti-Terrorist Display Case for the *Mona Lisa*," *Art Newspaper*, no. 149 (July–August 2004): 20.

5. Museum employees and slide librarians tell of thieves pilfering from their holdings and then seeing the lost images show up for sale on eBay or Corbis.

has always been an embattled legal zone: balancing the so-called natural property rights of an individual against the broader interests of a community. Of course, the framers of the Constitution thought we could have it both ways, and they tried to achieve a delicate balance, following English law, by opening up the property system to include the gradual commodification of products of the mind through the law.

Some of us, though, are never satisfied: Ever since the drafting of section 8, which sets a limit on copyright terms and provides for a public domain, there have been many to balk at the idea of imposing any kind of restriction whatsoever on a citizen's right to his or her own property. The results are copyright terms now so prolonged that something enters the public domain only when there's absolutely no living soul left with the nerve to put claim to it and the quaint belief that the brain's every issue onto canvas or clay or strewn around a gallery floor must be worth *something*. Charges of "piracy" are rampant for so-called infringement of ownership rights related to everything from a family snapshot posted on the Internet to photographs of old master paintings hanging in museums. "You can license a building, and you can probably license your children to Coca-Cola," said Garrett White in a recent issue of *Publishing Trends*. "It has . . . to do with the gradual commodification of everything."[6] Legal critics from Virginia Rutledge to Lawrence Lessig warn that in today's commercialized society "what is truly being pirated is our tradition of 'free culture.' "[7]

Significant activity centers on the status of reproduction photographs of artworks that are in the public domain. Ascertaining whether or not such a photograph—be it emulsion-based or digital—can itself be copyrighted is tricky, because you are talking about media for which the lines of function often blur.

6. "Steal This Image: Museum and Art Book Publishers Wander in Copyright's Wild West," *Publishing Trends*, December 2001, http://publishingtrends.com/copy/0112/0112stealthisimage.htm.

7. Virginia Rutledge, "Free for All," *Bookforum*, October/November 2004, 30–31; Lawrence Lessig, *Free Culture: How Big Media Uses Technology and the Law to Lock Down Culture and Control Creativity* (New York: Penguin, 2004).

The Nature of the Photographic Reproduction

The photograph is today the primary way to publish a unique work of art.[8] A photographic reproduction is thus a *surrogate* image[9] if its purpose is to record the exact physical appearance of the underlying work. Obviously, a photo reproduction involves a change of medium from the underlying artwork unless that work is also a photograph. There exist two classes of photo reproductions:[10]

- Those that are themselves creative. Many photographs that document *three-dimensional works* such as sculpture or built architecture qualify for copyright protection because making them requires creative choices by the photographer. She will, for example, choose a point of view for making the photograph in order to emphasize some element of the underlying work. She may employ evocative lighting or rent a helicopter to photograph a skyscraper, resulting in an *interpretative* image that is a unique intellectual expression (fig. 6).[11]

- Those that are slavish copies. Photographs that document two-dimensional artworks such as paintings, drawings, prints, and fine-art photography usually fall into this category. The aim of this class of photograph is to precisely *record* the underlying work. Figures 4 and 5 (*The Laughing Cavalier* and the *Mona Lisa*) are prominent examples. There is mounting legal evidence that these photographs do not qualify for protection under either U.S. or British law because they do not exhibit a minimum amount of originality.

8. Video recording is another way and as an interpretative mode is copyrightable.

9. For an excellent synopsis of this issue, see Alan Kohl, "Copy Photography Computator," http://www.vraweb.org/computator/welcome.html.

10. I am *not* referring here to new prints pulled from old plates or negatives, such as fine-art photographs. Those are a different matter. Some may qualify for copyright protection and are considered works of art in their own right. Consult a legal expert when you are trying to ascertain the status of later runs of master photographs or graphic works.

11. Photographs of flat two-dimensional works may also fall into this category if they are *expressive* in nature and transform the appearance of the underlying work. See note 18 re: *Schiffer Publishing, Ltd. v. Chronicle Books,* LLC, U.S. District Court for the Eastern District of Pennsylvania, 2004.

FIGURE 6. Anonymous (Chinese), *Chimera* (tomb figure), Western Han dynasty (206 BCE–9 AD), gray earthenware, slip-coated with polychrome pigments, 22.2 cm high × 43.8 cm long, ¾ view. The Art Institute of Chicago. Gift of Stanley Herzman in memory of Gladys Wolfson-Herzman; Avery Brundage, Louise Lutz, and Russell Tyson Endowments, 1997.337. Photograph by Robert Hashimoto, © The Art Institute of Chicago. A recent photograph of a work of sculpture that is in the public domain is normally protected by copyright. In this figure, the Art Institute of Chicago owns the copyright to the photograph made by Hashimoto on a work-for-hire basis. Rules may vary in non-U.S. countries. Image provided as a TIFF file. Fee paid: use and copyright to the Art Institute, $43.

Many writers and publishers thus feel justified in copying these photographs for inclusion in books and articles without asking permission to do so.

Still, the people and institutions that make and license these humble copies push for their ennoblement by claiming copyright protection for them, and on the face of it, this seems harmless enough, doesn't it? In fact, it may seem downright petty to deny some sort of protection for this kind of effort. But there is more involved here than the pocketbook. What does it mean, in a larger sense, to claim one can copyright a copy? What does it do to the quality of cultural discourse? If the copyright of a work in the public domain has lapsed, why should reproductions of that work qualify for protection? Copies, not auratic in their own objecthood, are now relentless in their implications, putting the entire basis of copyright at risk.

Legal ink has been spilled on this problem, but probably not enough. Clashes between property owners and users are usually too petty to litigate, so when the stakes are high enough to warrant a full-blown lawsuit, it is an important occasion.

Bridgeman Art Library, Ltd. v. Corel Corp., 1998. One of the most controversial cases in recent years is *Bridgeman v. Corel.*[12] In 1998 the Bridgeman Art Library, a British firm, filed suit in U.S. District Court against the Canadian software company Corel Corporation. Bridgeman was suing Corel for what it perceived to be an infringement of British copyright law: Corel had, without seeking Bridgeman's permission, published on a CD-ROM several color reproductions of two-dimensional artworks in the public domain, including Frans Hals's *The Laughing Cavalier*, owned by the Wallace Collection in London. The Corel images had been made from color transparencies owned by the Bridgeman Library.

If you are wondering why a British firm would seek recompense from a Canadian corporation through a U.S. court, it is probably because the infringement occurred in the United States. At issue was whether an exact photo reproduction of an artwork is itself an original work and therefore protected by copyright law.

Lewis A. Kaplan, presiding judge in the case, ruled, through two rounds of hearings, for Corel, ultimately declaring that the photographs distributed by Bridgeman in the form of transparencies were a product of "slavish copying" and did not reflect "the modest amount of originality required for copyright protection. . . . As the Supreme Court indicated in *Feist*, 'sweat of the brow' alone is not the 'creative spark' which is the *sine qua non* of originality."[13] Nor did he accept Bridgeman's argument that because the reproductions involved a change of medium from the original artworks (mostly oil paintings), they qualified for copyright protection. He remarked that a change in medium, "standing alone," is immaterial.

Though U.S. courts are not obligated to decide cases in light of British law, the judge took pains to explicate why Bridgeman's

12. *Bridgeman Art Library, Ltd. v. Corel Corp.*, 36 F. Supp. 2d 191 (S.D.N.Y. 1999).

13. In *Feist*, Judge Kaplan is referring to the 1991 U.S. Supreme Court decision *Feist Publications, Inc. v. Rural Telephone Service Co.*, 499 U.S. 340 (1991). The case

claim was as questionable under current British law as it was under that of the United States. There had been considerable case law on similar matters in Great Britain, some of it quite recent.[14] Among other points, Bridgeman's attorneys had cited as a British precedent *Graves' Case* of 1867 in which the presiding judge had determined that a photograph made of an engraving was "an original photograph" and therefore protectable, but Judge Kaplan pointed out that the plaintiff had overlooked "the antiquity of *Graves' Case* and the subsequent development of the law of originality in the United Kingdom."[15]

Museum Reaction. Judge Kaplan's decision sent shock waves through museum communities on both sides of the Atlantic. At stake were

centered on the problem of whether or not a telephone directory, which assembles information but does not create it, can be copyrighted. The Court found that it could not, declaring the "sweat of the brow" doctrine to be inconsistent with the Patent and Copyright clause of the Constitution. Judge Kaplan's decision can be viewed at http://www.law.cornell.edu/copyright/cases/36_FSupp2d_191.htm.

Judge Kaplan noted, too, in tracking the legal history of this issue in U.S. law, that "in *Burrow-Giles Lithographic Co v. Sarony* [1884], the Supreme Court held that photographs are 'writings' within the meaning of the Copyright Clause and that the particular portrait at issue in that case was sufficiently original—by virtue of its pose, arrangement of accessories in the photograph, and lighting and the expression the photographer evoked—to be subject to copyright. The Court, however, declined to decide whether 'the ordinary production of a photograph' invariably satisfies the originality requirement. While Judge Learned Hand later suggested that the 1909 Copyright Act protected photographs independent of their originality, his view ultimately was rejected by the Supreme Court. Nevertheless, there is broad scope for copyright in photographs because 'a very modest expression of personality will constitute sufficient originality.' 28. 111 U.S. 53, 4 S. Ct. 279 28 L. Ed. 349 (1884)."

14. British case reference in note 49 of Kaplan's decision: 1 A.C. 217 (P.C. 1989), 3 All E.R. 949, 970 (1988):

In the words of the Privy Council in *Interlogo AG*, "there must . . . be some element of material alteration or embellishment which suffices to make the totality of the work an original work." As the Privy Council wrote . . . "skill, labor or judgment merely in the process of copying cannot confer originality. . . ." The point is exactly the same as the unprotectibility under U.S. law of a "slavish copy."

15. "It is submitted that *Graves' Case* (1869) LR 4 QB 715 (photograph of an engraving), a case under the Fine Arts Copyright Act 1862, does not decide the contrary,

revenues from licensing fees, and there arose a carefully crafted chant infused with legalistic language that museum-owned photographs of works of art would now, in the wake of *Bridgeman*, be more vulnerable to "piracy" than ever.[16] Museums and developers of software for online picture research and the management of institutional collections objected, moreover, that the *Bridgeman* decision compromised their enduring concern to monitor the integrity of reproduction images of works in their collections.[17]

Whether or not one views *Bridgeman* as the last word on reproduction images is not my precise concern. There have certainly been other related cases that have involved different decisions.[18] But it

since there may have been special skill or labour in setting up the equipment to get a good photograph, especially with the rather primitive materials available in those days. Although the judgments do not discuss this aspect it may have been self-evident to any contemporary so as not to require any discussion. If this [conclusion] is wrong it is submitted [anyway] that *Graves' Case* is no longer good law and in that case is to be explained as a decision made before the subject of originality had been fully developed by the courts."

Judge Kaplan also cited Lord High Justice Hugh Laddie: ". . . it is submitted that a person who makes a photograph merely by placing a drawing or painting on the glass of a photocopying machine and pressing the button gets no copyright at all; but he might get a copyright if he employed skill and labour in assembling the thing to be photocopied, as where he made a montage. It will be evident that in photography there is room for originality in three respects. First, there may be originality which does not depend on creation of the scene or object to be photographed or anything remarkable about its capture, and which resides in such specialties as angle of shot, light and shade, exposure, effects achieved by means of filters, developing techniques etc.: in such manner does one photograph of Westminster Abbey differ from another, at least potentially. Secondly, there may be creation of the scene or subject to be photographed. We have already mentioned photo-montage, but a more common instance would be arrangement or posing of a group. . . . Thirdly, a person may create a worthwhile photograph by being at the right place at the right time. Here his merit consists of capturing and recording a scene unlikely to recur, e.g., a battle between an elephant and a tiger. . . ." Judge Kaplan's quotation comes from Hugh Laddie, Peter Prescott, and Mary Vitoria, *The Modern Law of Copyright and Design*, 2nd ed. (London: Butterworths, 1995), 238, § 3.56. A third edition was published in 2000.

16. Peter Wienand, Museum Copyright Group Chairman, "Copyright in Photographs of Works of Art," http://www.mda.org.uk/mcopyg/bridge.htm.

17. Ibid.

18. A case that *Bridgeman* opponents sometimes cite is *Schiffer Publishing, Ltd. v. Chronicle Books* (which also invokes *Feist*). In that case, a U.S. district court ruled

would be a mistake to ignore *Bridgeman*. It is a high-profile case that confronts important questions about copyright fundamentals in an era newly preoccupied with the gathering and circulation of massive amounts of information. Even if one disagrees with Kaplan, it's worth thinking carefully about the trade-offs that pertain when we say that copies themselves qualify as works of intellectual property protected by the limited monopoly that copyright offers. If that is the case, what next? Here's what, exactly this: The dynamic system of authorship and copyright protection grinds to a halt the moment we decide that copying constitutes a valued mode of creative expression. Following this peculiar logic, there is nothing, then, to impede me from duplicating an "original" copy and declaring my iteration an original too. Moreover, short of some very clever feat of detection, how would one discern whose copy is whose?

Of course, much of the current legal flurry over the public domain revolves around the making of digital copies in cyberspace. As collectors trade film for binary bits, they are joining far more powerful allies in hammering out the rights that attend the digital—and not just the mechanical—age. How long it will take a judge to declare the *Bridgeman* decision—which involved digitizing copies from transparencies—"antiquated," like *Graves' Case* before it, is anyone's guess, but mine is that it will be sooner rather than later.[19]

in favor of Schiffer, which claimed that Chronicle Books had infringed on the copyright of some photographs it had made of quilts (essentially flat two-dimensional works) and published in a series of books, by scanning and republishing them without permission. However, the basis of Schiffer's claim was that the photographs it had made were expressive and were intended to appeal to viewers; there had never been an intent to maintain fidelity to the underlying work, i.e., to simply record the facts as in *Bridgeman*. In truth, many of the photographs would have been judged to be inaccurate viewed against the original quilts. (Quote, from *Schiffer*: "The tone and value of colors in the Schiffer photograph[s] differed from those of the actual fabric swatch.") The presiding judge, Berle M. Schiller, took pains to demonstrate how the material facts and issues in the instant case differ from those in *Bridgeman*. Thus *Schiffer* would appear not to contradict *Bridgeman* but to build upon it, to reinforce that there must be some interpretative dimension or spark of originality in a work, be it ever so modest, for it to qualify for copyright.

19. A number of museums choose to ignore *Bridgeman* altogether, though that decision was based on ample precedent: decisions of the U.S. Supreme Court as well as those of other courts. Some museums argue that because *Bridgeman*

Law related to the production and dissemination of intellectual property in this new environment is evolving with great rapidity, for today owners must consider what happens when their property is made available to whole franchises of users, not just the singular scholar or publisher. Electronic commerce offers all kinds of ways of doing business, but, as we know, it has also created ingenious opportunities for theft—and on a very grand scale. So much so that in October 1998, the same year that Judge Kaplan rendered his decision in *Bridgeman v. Corel* and a mere day after Congress voted to extend the term of copyright protection by another twenty years,[20] our federal legislature also passed into law the Digital Millennium Copyright Act (DMCA). The DMCA protects against hacking technologies used to gain unauthorized access to material in copyright. For example, the DMCA makes it illegal for anyone to "publish" software that has the primary purpose of decrypting or circumventing digital security codes used by intellectual property owners.

While the DMCA is meant to inhibit breaches in digital security, it does nothing to hinder content providers from locking down objects in the public domain by batching them with copyrighted materials and storing everything in electronic repositories with strictly controlled access.[21] Because "the widespread use of digital technologies makes it possible for everyone with a computer on his desk to copy and transmit information at almost no cost," says Jonathan Fanton, president of the John D. and Catherine T. MacArthur Foundation, "the [new] technologies also make it possible to block access to important information, including data developed at public expense."[22]

Further, though the DMCA is minted with the jargon of a new frontier, it seems curiously vacant of language to balance the rights of

was tried in the state of New York—even though in a federal court—the decision doesn't apply to other states.

20. The Copyright Extension Act (also known as the Sonny Bono Act) increased the term of copyright protection for works created since 1978 from "life of the author plus fifty years" to "life plus seventy."

21. ARTstor is an exemplar.

22. MacArthur Foundation website http://macfound.org/announce/press _releases/2_12_2003_4.htm.

individual ownership against a "public need" or "common good"—
trace evidence of a natural generosity that we would like to think lin-
gers on in modern communities.

The newest laws and treaties also reflect a general erosion of
the test of originality—or any test, for that matter—to ascertain
what material qualifies for copyright.[23] It is precisely the impact of
these new laws that, in 2003, prompted the MacArthur Foundation
to designate a series of grants for work on issues related to intel-
lectual property rights and "the long-term protection of the pub-
lic domain."[24] The MacArthur "initiative is designed in light of the
need for a new set of laws, regulations and practices that appropri-
ately *balance* the needs of the creator of information for adequate
compensation and the needs of the public to have access to that in-
formation [emphasis mine]."[25]

Contracts

From the simple fact that collectors control access to the public-
domain objects they own, they can then employ contracts to expand
their interests in its surrogate images, copyrightable or not. Some
institutions have the idea that if they just say they own the copy-
right to reproductions of public-domain works and consistently put
forth claims that not only go unchallenged but are acknowledged by

23. The European Parliament issued a directive for protection of collections of
facts and databases assembled by "sweat of the brow"—such as telephone books.
So far, these collections of facts are not protected by copyright in the United States,
but the debate continues. For a broad view of the situation and of the role that
the World Intellectual Property Organization (WIPO) can play "in setting innova-
tion policy worldwide," see James Boyle, "A Manifesto on WIPO and the Future of
Intellectual Property," *Duke Law and Technology Review*, September 8, 2004. Pub-
lished under the terms of a Creative Commons license, http://www.law.duke.edu/
journals/dltr/articles/2004dltr0009.html. For specific discussion of the European
directive, see Matt Block, "The Empirical Basis for Statutory Protection After the Eu-
ropean Database Directive," Center for the Study of the Public Domain, Duke Law
School, posted spring 2005, http://www.law.duke.edu/cspd/papers/empirical.doc.

24. For details on specific programming, visit the MacArthur Foundation web-
site, http://macfound.org/programs/gen/special_interest.htm.

25. Ibid.

FIGURE 7. Petrus Christus, *A Goldsmith in His Shop, Possibly Saint Eligius* (1449). Oil on oak panel, overall 39⅜ × 33¾ in. (100.1 cm × 85.8 cm), painted surface 38⅝ × 33½ in. (98 × 85.2 cm). The Metropolitan Museum of Art, Robert Lehman Collection, 1975 (1975.1.110). Photograph, all rights reserved, The Metropolitan Museum of Art. This painting is in the public domain. Nevertheless, the museum asserts copyright to the reproduction image loaned for this book, through private contract. Image provided as a black-and-white glossy photograph. Fee paid: use and alleged copyright to the Met, $25.

writers who agree to use exact credit lines in exchange for rights to publish images, then it will eventually be accepted as so. For example, check out the caption for figure 7, a reproduction of a painting by Petrus Christus in the Robert Lehman Collection of the Metropolitan Museum of Art. Note the woolly asseveration: "Photograph, all rights reserved, The Metropolitan Museum of Art."

One would presume that "all rights reserved" means all *legal* rights in the photograph, right? But, in fact, the Met has omitted to include what they really mean in the caption. If you take up the licensing

agreement I signed in order to obtain a reproduction-quality copy of that public-domain painting and hew your way through the fine print, you'll learn that I made a bargain "to prominently place on all copies of the reproductions that are distributed to the public *a notice of the Museum's copyright ownership* [emphasis mine], which notice with respect to each separate reproduction shall read as follows: 'All rights reserved, The Metropolitan Museum of Art.'"[26] The copyright claim to the reproduction is latent, like a virus patrolling the bloodstream. At some point, all those signed contracts with the Met could conceivably be bundled together with millions of others just like them as evidence that the intellectual property system of this country has changed, that it has already been revised by the individual decisions of millions of citizens, and that statutory law ought to follow suit. The strategy may be working—at least to the extent that many intellectual property authorities now dance around the issue. You will see, wherever you turn for advice, nervous warnings:

> Even if a depicted work is in the public domain, a photographic reproduction of that work *may* carry additional layers of copyright protection claimed by photographers, publishers, or museums. As many scholars can attest, the procedure of separating these layers and seeking requisite permissions for the sake of publication can be complex, painstaking, and financially onerous. [emphasis mine][27]

> It should be noted . . . that photographs of works of art in the public domain *may* themselves be copyrighted and will likely require a license for publication, even though the public domain works which are the subject of the photos are no longer protected. [emphasis mine][28]

What an ugly mess. To hell with it. Maybe we should follow the lead of the Dutch, who sensibly recognize that the public domain is the public domain. Everyone knows what that is, so let's not belabor

26. Form sent with "Invoice for Black & White Photography," the Image Library, the Metropolitan Museum of Art, "Conditions for Reproduction for Editorial Use," received October 7, 2005.

27. CAA Committee on Intellectual Property, *News*, January 2004 Web edition, http://www.collegeart.org/caa/news/2004/Jan/CIPcommittee.html.

28. Artists Rights Society (ARS), "Copyright Information," http://www.arsny.com/basics.html.

the obvious. Because the public domain belongs to everybody, photographs of public-domain artworks cannot be copyrighted . . . period.

For the Dutch, this poses something of a Gordian knot, however: if images of artworks in the public domain indeed belong to everybody, it can then be inferred that they also belong to nobody and therefore cannot be bought or sold. For all that, they can, reason the Dutch, be *loaned*—to the tune of a big fat fee, among the highest on Earth, and you'll be prevented from making photographs yourself, because, as we say, the world inside a Dutch museum is for everyone rather than anyone, meaning it is not for you.

What can you do? Ignore museum policies and go shutter-bugging through their galleries flashing away, a posse of guards on your tail? Sue collectors over unfair licensing agreements in the name of free speech? Do you want to take it that far? Well, maybe you do, and maybe you should. Or if you don't want to jump into a lawsuit all by yourself, you might want to join an organization that resists attempts to change the law to clarify (more than is already the case) that contracts trump rights in intellectual property given by the Constitution. But don't expect your publisher to stand behind you. It's all well and fine to incite authors to riot, to challenge the institutions that have come to dominate the public domain and have arrogated to themselves the role of its custodian, but most members of the fourth estate are deeply pragmatic, not to mention cowards. That includes me. The painful truth is that you will find in my captions no willful refusal to include the exact language prescribed by lenders of the illustrations. Like everyone else, I just want to get my book published. Of course, the eventual effect of such laissez-faire may be to seal off the public domain entirely as more and more each year the problem confronting scholars is not so much one of copyright but of access and permission. If we can ever assess the dilemmas of social balance, then perhaps we are on course to prescribing a correction.[29]

But I'm not holding my breath.

29. In chapter 9, we will see how fair use is the facility in the law that mitigates excesses of ownership.

6 * The Forbidden Image: Museums and an Empire of Signs

MANY OF US live in a world of wishful thinking. To wit, a vivid scene: You are studying a group of drawings in the archive of a famous art museum. Signs that plainly forbid photography are posted about the spotless room in several languages. The archivist, who presides over her treasures with a queenly demeanor, enforces the injunction with an eye as perspicacious as the Hubble, but, damn it, there's that one tiny drawing by an obscure artist from the sixteenth century . . . you thumbed across it by *accident*, for heaven's sake, and judging from the cloud of dust that escaped from the archival box when you opened it, no one had touched that drawing in thirty years or more. Flush with discovery, you decide to make it the crux of an article that you've waited until the last minute to write. Time is short; the publisher is pestering you with e-mails, but the grand doyenne who works here has explained it will take at least two months and two hundred dollars to produce an adequate print or digital file. Her staff has a great backlog of work, you see. You'll have to wait your turn.

"Take the picture and run." It's what you're thinking, isn't it? With a flick of the wrist, a tiny digital camera slips from your sleeve and you photograph the dusty scrawl right there under the archivist's nose (well, granted, she isn't looking), even though institutional policy prohibits it. And why not? What's the harm? Who's going to know? After all, it's a negligible drawing destined to appear in a dull article in a minor journal. Besides which, the drawing is in the

public domain, and if push comes to shove, the law is on your side, right? Well, in theory, perhaps, but the real world is rife with incongruities between different areas of the law. The legal sands beneath your feet can quicken rather drastically the moment you step into a museum—or into a corporate office or onto a university campus, for that matter. Institutions have their dicta irrespective of what you may think is proper.

Many attorneys, invited to analyze the scene unfolding before us, would be apt to invoke what is known as the "law of forbearance," the idea that the courts prefer not to intervene in the internal affairs of a corporate body, which, like an individual household, has its own internal economy and policies. In other words, the museum is a small country unto itself and would be well within its rights to have you charged with trespassing should it so choose. When you purchase a ticket to its galleries or ask to be admitted to the archive, you are entering into a compact that obliges you to abide by certain rules, including those that govern viewing and restrictions on photography. Anyhow, that's the broad canvas upon which we are painting our narrative picture. But there is still that niggling question: If you quietly break a rule, who's going to know?

Let's go back to you hunched over the drawing with your little camera.

A furtive glance over your shoulder, quick. Then . . .

Click. The shutter does the dirty. You check to see if the archivist's antennae have started to quiver, but, no, they remain retracted beneath her coif.

Ha-ha. Success. You haven't been caught, at least not yet. Stowing the camera, you are ready to make off with the coveted image.

Mission accomplished!

Oh, really? Do you think so? Are you feeling very smug?

A pity, because here's what can come of such elopements.

Let's retreat for a nostalgic moment to the Nixon era of the early '70s, when the air was filled with the Cold War and paranoia was in bloom, when we were all reading Foucault and glowing in the discomfiting belief—no, no—in the absolute certainty that invisible eyes were watching.

There appeared in the wake of Watergate and the collapse of faith in American government a spy thriller titled *Three Days of the Condor*, starring Robert Redford and Faye Dunaway, the two biggest hotties of the day. The point of bringing it up here is to examine the clandestine vigilance practiced by some of our elite institutions. There is a moral and we'll get to it, but first . . . roll 'em.

Scene: New York City. It is winter, a frosty Friday morning.

Enter Robert Redford, coming from afar on a mini-powered motor scooter, buzzing through morning rush-hour traffic in the dense core of Manhattan. We sense instantly that he is a brainiac from the enormous aviator-style wire-rimmed glasses with thick lenses he wears and the blue jeans that ride up ridiculously above his ankles as he putters along (fig. 8).

Redford's character, Joe Turner, is on his way to work, and he is running late per usual (a character flaw that is about to save his life). Veering in and out of traffic amid horn honks and clouds of exhaust, eventually he slows his scooter and pulls up to the curb in front of the welcoming facade of an elegant town house. This is the home of the American Literary Historical Society. It is where Turner works. Bounding up the stone steps of the venerable enclave, he rings the doorbell and waves to the closed-circuit camera, signaling some invisible gaze within to grant him admittance.

FIGURE 8. *Three Days of the Condor*: Robert Redford, as Joe Turner, on his way to work. Frame capture by Kimberly Pence. JPEG. Fair use. Fee paid: $0.

Inside the Historical Society, a distinguished-looking reception-
ist with snowy hair pauses in her typing to buzz him in (fig. 9). And
yet . . . everything is not quite what it seems. As the receptionist's el-
derly fingers pull open the drawer of her desk to reach for the buzzer,
we notice, secreted within the interior, a gun. It's not just any wee
pistol, but a .45 automatic the old lady is packing (fig. 10). And what
about that unfiltered cigarette dangling from her lip?

But before we can examine the scene with any care, here comes
Turner bounding through the door, *out of the cold* (note the symbol-
ism), frisky, tearing off his wool cap and scarf. Remember, he is late,
and in the next ten seconds we learn through a bit of pithy banter

FIGURE 9. *Three Days of the Condor*: Inside the American Literary Historical Soci-
ety. Frame capture by Kimberly Pence. JPEG. Fair use. Fee paid: $0.

FIGURE 10. *Three Days of the Condor*: The gun in the receptionist's desk drawer.
Frame capture by Kimberly Pence. JPEG. Fair use. Fee paid: $0.

that he is an intelligence analyst employed by the federal government and that the American Literary Historical Society is actually a secret cell of the CIA. In this stately brownstone, in the guise of philologists, Turner and his nerdy colleagues while away the hours reading books and scanning them into a nakity-nak computer they affectionately call "the Machine."

"We read everything . . . ," he later explains to Faye Dunaway as he is waving a gun in her face and tying her up. "Novels, adventures, journals. Everything published. We're searching for codes and leaks . . ."

What, you might be asking, does the CIA have to do with the museum archive in our story? What, indeed.

I'd be willing to wager that if you are a culprit with the temerity to have committed such a brazen swindle as we witnessed in that archive a few pages ago, you may find that, one day, there comes a sharp rap on your door and, thrust into your hands, a registered envelope from the museum that, the moment you unseal it, unleashes a strident chatter, a voice all in a temper, upbraiding you, perorating your wrong, and demanding restitution this instant—do you hear?

Question: How could the museum have known what you did? What are the rights and permissions employees doing behind that blue door, anyway? Were they watching you on a surveillance monitor? Or is the office jammed with eager young operatives fresh out of college, crawling through pages with magnifying glasses and feeding journals and books into computers, looking for "leaks"—objects in the museum's purlieu that may have been published without consent?

Sometimes it seems so. Several years ago I acquired translation rights to a book published in French that included a minor eighteenth-century print. The print was hardly a unique work and, in fact, there were versions of it all over the world; apparently the museum to which I allude possessed one of them, though I didn't know it at the time—nor would I have cared if I had. Having secured printing film without restriction from the French publisher, I possessed the image, and the underlying work was certainly in the public domain. Neither I nor anyone else at the Press questioned our right to publish it.

Too bad for us. The kids behind the blue door viewed it differently. Having come upon the image in our book, they wrote a bullying letter threatening to sanction the *entire* university unless we paid a penalty for publishing the work without the museum's permission. In a menacing tone, they explained that if we refused, "Steps would be taken": the faculty wouldn't be able to order slides from the museum or do research in the archives. In fact, any doings the museum was having with the university system would be suspended *immediately* if we didn't cough up—what was it?—a hundred dollars.

Question: Did the museum have a legal right to come after us? Did they *need* a legal right? And, by the way, how much did they spend trying to collect that hundred bucks?

Furthermore, since the print was owned by several museums, why was this one so sure the image came from them?

Good questions without good answers. Law aside, scholars and publishers can't win these kinds of battles even when they're right because they depend upon the bonhomie of cultural institutions to get the job done. Some institutions, if they catch wind of your industrious excavations, will try, over and above any penalty they try to exact, to pin you with what is termed a "repro fee." The repro fee represents a not-so-subtle claim to the right to authorize the reproduction of a work, which, the last time I checked (about three minutes ago), is the functional basis of copyright and not an automatic privilege of the owner of the material object. Oh well.

In December 1990 Congress passed the Visual Artists Rights Act (VARA).[1] The purpose was to protect a visual artist's work from being destroyed or altered by the owner of the work without the consent of the artist. This is the primary moral right of artists in the United States. Many other countries offer more substantial rights to artists in their own works, including what is termed *droit de suite*. In France, for example, an artist or his estate is paid a percentage of the revenue from resale of his work on the secondary market. (The only place in the United States where this holds is in California.)[2]

Most intriguing about VARA is what it defines to be a work of visual art. Paintings, drawings, prints, fine-art photographs, and sculpture in single copies or limited editions make the cut, but motion pictures, technical drawings, books (what about artists' books?), architecture, applied arts—anything that is actually used—do not. Obviously the definition is extremely narrow and does not begin to address the variety of productions that now dominate the art scene and current discourses of visual culture. What about multimedia installations? Or digital art? Or functional art where concepts of art fuse with those of craft? Would a glass sculpture in the shape of a vessel by the artist Dale Chihuly be protected by VARA? Probably. But what about a bowl by the great Tewa potter María Martinez (fig. 11)? In the Tewa language, there is no word for "art." Martinez meant for her pots to be used. Nevertheless, prices for them are as high, if not higher, than those for a Chihuly, and Martinez is considered to have been just as innovative in her medium as Chihuly is in his.

In a more conventional sense, how does one evaluate the circumstances whereby Robert Rauschenberg took a drawing by Willem de Kooning and

FIGURE 11. María Martinez holding polychrome "Avanyu" olla (MRM1984-74-1). Photo courtesy the Millicent Rogers Museum. The Martinez family gifted this image to the museum with a transfer of copyright. The museum kindly provided a high-resolution JPEG file and waived copyright and use fees because the Press is a nonprofit publisher.

1. 17 U.S.C. sec. 106A.

2. For a lively discussion of moral rights in different countries, see Joseph L. Sax, *Playing Darts with a Rembrandt: Public and Private Rights in Cultural Treasures* (Ann Arbor: University of Michigan Press, 1999).

FIGURE 12. Robert Rauschenberg, *Erased de Kooning Drawing* (1953). Traces of ink and crayon on paper, with mat and label on gold-leaf frame, 25¼ × 21¾ × ½ in. (64.14 × 55.25 × 1.27 cm). San Francisco Museum of Modern Art. Purchased through a gift of Phyllis Wattis. Art © Robert Rauschenberg/licensed by VAGA, New York, NY. Image provided as a black-and-white glossy photograph. Fees paid: copyright for the drawing to Rauschenberg/VAGA, $130; use to SFMoMA, $40.

erased it to create the *Erased de Kooning Drawing* (fig. 12), and subsequently asserted his authorship of it? Rauschenberg's prank served all kinds of political and symbolic objectives. It was an act of banality intended to signal the end of what was coming to be perceived as an orthodoxy of traditional modernism and the ascendance of a new, impious generation of artists. It also strove to draw attention to the process of making and unmaking art. De Kooning, by the way, chose the drawing for Rauschenberg to alter. Erasing the drawing certainly affected the market for it, but the drawing was purchased anyway, as a work authored by Rauschenberg, and is now in the collection of the San Francisco Museum of Modern Art.[3]

..

3. For an account of this event, see Mark Stevens and Annalyn Swan, *De Kooning: An American Master* (New York: Knopf, 2004), 358–60. For a discussion of its significance, see Leo Steinberg, *Encounters with Rauschenberg* (Chicago: Menil Collection and University of Chicago Press, 2000).

SIDEBAR: COPYRIGHTING ARCHITECTURE

A work of architecture (including landscape design) is almost always copyrighted in the name of the architect or the architectural firm that employs her. What this means is that you can't duplicate the structure itself, not that you can't photograph it or publish your photo (fig. 13).

A large part of the copyright in a building exists in its plan: in the drawings and hybrid visual models. These have long been "copyrightable as pictorial or graphic works,"[1] and to publish them you must obtain permission from the copyright holder.

There is a specific provision in the Architectural Works Copyright Protection Act that exempts the copyright holder from preventing photos of built works located in places that can be viewed by the public, but there exists considerable confusion about photographs of architecture that might pass for

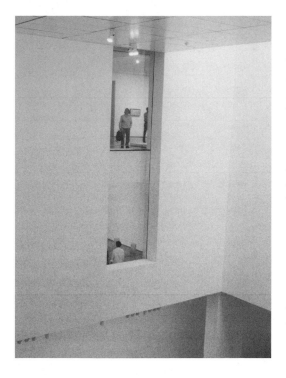

FIGURE 13. MoMA's new interior space (atrium view), New York City, 2005. The copyright to this photograph belongs to the photographer, Kimberly Pence. Permission to publish it was not sought from MoMA or from the architect, Yoshio Taniguchi. MoMA allows photography in its galleries, though it prohibits the use of a flash. In the United States, one can freely photograph built works accessible to the public. Image provided as a JPEG. Fee paid: $0.

1. William S. Strong, *The Copyright Book*, 5th ed. (Cambridge, MA: MIT Press, 1999), 19. See, too, the Architectural Works Copyright Protection Act, title VII of the Judicial Improvements Act of 1990, Pub. L. No. 101-650, 104 Stat. 5089, 5133, enacted December 1, 1990.

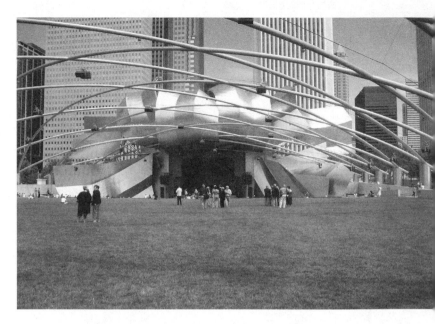

FIGURE 14. Frank Gehry's Bandshell in Millennium Park, Chicago, 2005. Photograph made with a handheld camera. © Kimberly Pence. Permission to publish this image was not sought from the city of Chicago or from Frank Gehry. Image provided as a JPEG. Fee paid: $0.

sculptural art, such as Frank Gehry's new bandshell in Chicago's Millennium Park (fig. 14). What separates it from the massive polished form by Anish Kapoor (*Cloud Gate*), which also graces this new public park in the country's third largest city? Typically, courts draw a distinction between sculpture and architecture on the basis of "habitability," but even this isn't always a satisfactory test. If one wants to split hairs, some sculpture can actually be "inhabited": *Cloud Gate*, for example, contains a pass-through intended by the sculptor to be part of the experience of the work, and certainly one can duck in there to escape a sudden rain shower.

A more useful legal criterion is "function." Gehry's structure functions first as a concert stage, making it a building. Kapoor's *Cloud Gate* can be construed as having primarily a decorative function, making it sculpture.

The enhancements of Millennium Park have been the subject of no little controversy ever since the park opened in 2004. It wasn't long before a story broke in the *Chicago Reader* that security guards were "shooing photographers out of the park" who had not obtained a permit from the city.² The

2. Ben Joravsky, "The Bean Police," *Chicago Reader*, January 28, 2005; and Ben Joravsky, "Pork in the Park," *Chicago Reader*, February 11, 2005.

guards were explaining to the photographers as they chased them away that the park's many enhancements were all copyrighted and that they were merely trying to protect artists' rights. (As it turns out, they were protecting the city's rights, which had an exclusive license from the artists to sell images of their work.) And yet the guards weren't stopping *everyone* who took a photograph, only those who set up a tripod. Apparently they had been taught that the litmus test of copyright is the presence of a tripod: a camera mounted on a tripod signals that commercial prospecting is afoot (which would include publishing images of the park) while a handheld camera does not.

Since that story broke, the guards at Millennium Park have been deeply schooled in the finer points of etiquette and copyright. The city is now projecting a kinder, gentler face to the public. Below (fig. 15), a "hospitality services" employee assists tourists by taking a snapshot of them standing before Anish Kapoor's *Cloud Gate*.

FIGURE 15. Tourists at Anish Kapoor's *Cloud Gate*, Chicago, 2005. Photograph made with a handheld camera. © Kimberly Pence. Permission to publish this image was not sought from the city of Chicago or from Anish Kapoor. The sculpture (which is not pictured in whole) is only one element in a larger scene and subject to fair use. Image provided as a JPEG. Fee paid: $0.

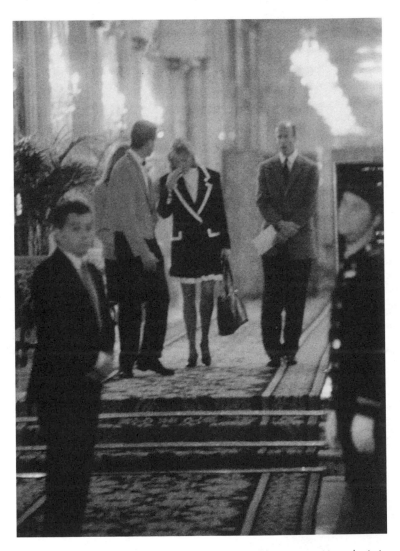

FIGURE 16. The Duchess of York before her regrettable moment. Here she is in Argentina, beautifully shod, financial adviser John Bryan upright at her side. It would be a mere month before the two were captured in far less elegant postures at a St. Tropez getaway. June 7, 1992. © Alfaqui de la Imagen/Corbis Images. Image provided as a JPEG. Fee paid: copyright to Imagen/Corbis, $260.

7 ⁑ *Those Toes: Privacy Woes and the Duchess of York*

THE ANTHROPOLOGIST had written a hot book, an astringent disquisition on the heroic figure of her kind in the popular imagination. Franz Boas, Margaret Mead, James Clifford, all there. Page after page of absorbing prose. The only thing lacking were some pictures, she said. Might she have a few?

Not many, mind you, just a scattering to illustrate one or two key points and to "break the monotony" of reading. (For this, consider, not illustrations, but writing shorter: shorter sentences, shorter paragraphs, shorter chapters.) The images she wanted were not art qua art in the traditional sense; they amounted to a couple of cartoons published in the *New Yorker*, a page from a comic book, and an advertisement for Crate and Barrel—a mere handful, but for all the time and money the anthropologist spent securing the rights, in the end they added little to her argument. The cartoons were fun for the reader, but for the author there was nothing fun in clearing what proved to be several major permission hurdles. Not only did the experience leave her hamstrung financially; the many ins and outs of negotiating licenses delayed publication.

Beyond the cartoons and ads, the author wanted to use one of her own photographs on the book's dust jacket. The picture seemed innocuous enough: it showed a young pregnant woman hand in hand with a toddler, the two of them strolling along Dempster Street in Evanston, Illinois. As to permissions, one would have thought it a

cinch. After all, the photo was the author's and hers to do with as she pleased, right?

Well, maybe and maybe not. There is a general belief that if you photograph someone in a recognizable likeness, you need a release to publish it. Certainly that is true if you make the photograph in a private space, but in public different principles come into play. What matters in the case of the pregnant woman and the child is the extent to which they were the subjects of the photograph. As it happens, in the original work they were only two of several figures in a wide-angle street scene; however, for the purpose of the dust jacket, the author wanted to crop the image to focus on the pair. The woman and the tiny girl would be serving as the public face of this controversial project without their consent. If the woman saw her face splashed all over the front of the book, how would she feel about it? And though the photograph seemed harmless enough to *me*, what if the young woman was actually underage and supposed to be off at convent school or something? What if her family didn't know she was pregnant? What if she was on the lam or fleeing an abusive husband who might trace her to Evanston by checking the photo credit line?

You never know.

Also, people possess certain *tangible* rights to their own images. Subjects have a stake in their own representation, and some courts have determined that the revenue potential implicit in embodiment gives *them*—not you—the right to control it. People have "personality rights," or rights of publicity, as it were.[1] In the United States, privacy and publicity rights vary from state to state and are not the

1. See the Library of Congress website, http://www.loc.gov/ammem/copothr .html: "The privacy right or interest of the subject is personal in character, that the subject and his/her likeness not be cast before the public eye without his/her consent, the right to be left alone. The publicity right of the subject is that their image may not be commercially exploited without his/her consent and potentially compensation." The Library of Congress recommends as further reading on the subject of privacy and personality rights: George Chernoff and Hershel Sarbin, *Photography and the Law* (New York: Amphoto, 1971); and John Schultz and Barbara Schultz, *Picture Research: A Practical Guide* (New York: Van Nostrand, 1991).

subject of federal law. If you don't respect these rights, you might just find yourself up to your neck in subpoenas and the astonished party to a lawsuit.[2]

However, what about all those paparazzi shots of celebrities caught being human? A starlet with bad hair and puffy eyes after a fifteen-hour plane ride from Australia? Or Sarah Ferguson sunbathing topless when she was the Duchess of York, eagerly besucked of toe by a man who wasn't her husband? Can the starlet and the duchess sue over those images?

Well, anybody can sue. The question is who will win? If the three cases presented here were each litigated in the United States, the plaintiff most likely to be awarded damages would be the pregnant woman—in the public's view, a veritable nobody. Celebrities have a far harder time protecting their privacy than do the rest of us. As the argument goes, because they trade on a public persona, because they make a living by the very fact of their fame, they are generally considered fair game when they appear in public.[3] But peek through their fence with your camera or wait for them in a tall tree overhanging their private swimming pool, and you are asking for trouble. Crash the wedding of Catherine Zeta-Jones and Michael Douglas to grab some snaps, and the trouble will be double-deep. Not only did you invade their privacy, they would claim in a lawsuit, but when those shabby shots were published in *Hello!* magazine, they served to undermine the market value of the formal photographs the star couple

2. One can't be sued for libel or slander after the subject has died. That's why those nude photos of Marilyn Monroe and that soft-porn movie in which she costarred with a Coke bottle didn't surface until after her death. It also explains those sleazy star biographies written by scorned lovers and ex-wives that invariably appear after a celebrity dies. By the way, libel laws are much more aggressive in Great Britain than in the United States. In the United States, the burden of proof in a libel case is placed on the plaintiff, who must demonstrate that a published statement about them is false and defamatory. In the United Kingdom, the burden is placed on the defendant to prove that a published statement is true.

3. Jacqueline Kennedy Onassis managed to obtain a restraining order against photographer Ron Galella, but on the basis of harassment. Galella was forbidden to come within five hundred feet of the former First Lady, even when she was walking along a public street.

had already licensed to the slick British rag *OK!* and did "potential harm to their reputation given the shoddy quality of the pictures, which [Zeta-Jones] called 'sleazy and unflattering.'"[4] In the case's original verdict, London High Court Justice John Lindsay seemed to agree, noting that "distress was caused to Mr. and Mrs. Douglas" (figs. 17a and 17b).[5] He also ruled that *Hello!*'s actions had indeed discounted the commercial value of the wedding and charged the magazine to pay *OK!* a million pounds in damages.[6]

> "[The wedding was] a valuable trade asset, a commodity the value of which depended, in part at least, upon its content at first being kept secret and then of it being made public in ways controlled by Miss Zeta-Jones and Mr. Douglas," the judge declared.[7]

The Zeta-Jones and Douglas suit turned out to be a landmark case in Great Britain. It marked the first time that the Court of Appeals in London recognized any kind of right to privacy. Prior to that there existed no such recourse: in 1992, when the Duchess of York tried to block the English press from publishing those unfortunate toe shots, she was stunned to learn that there was no law that could help her. All was not lost, however, for the mortified and bediddled duchess: she went on to file—and win—a handsome $1.6 million suit in France against *Paris-Match*, which also ran the photos. France has very strong privacy laws; the French newspaper not

4. Josh Grossberg, "Catherine and Michael Court Victory," *E! Online*, April 11, 2003, http://www.eonline.com/News/Items/0,1,11607,00.html?tnews.

5. Ibid.

6. In a May 2005 appeal, the court waived the payment that *Hello!* was to pay to *OK!* as compensation for market value lost on the official wedding photographs. At the same time, the court upheld the celebrity couple's right to privacy but dismissed their request to increase the damages they would receive. Reuters, "*Hello!* Wins Zeta-Jones, Douglas Appeal," May 19, 2005, http://tvnz.co.nz/view/news _entertainment_story_skin/558983%3fformat=html.

7. Grossberg, "Catherine and Michael." However, as mentioned in the previous note, this decision was overturned on appeal by *Hello!* On May 19, 2005, Master of the Rolls, Lord Philips, ruled that *Hello!*'s publication of the photographs had not breached *OK!*'s commercial rights. And an appeal by the Douglases that their award for breach of privacy (£14,600) be increased was summarily dismissed.

FIGURES 17a & 17b.
Courtroom sketches
of (a) Catherine Zeta-
Jones and (b) Michael
Douglas testifying
at trial. © Elizabeth
Cook. Images cour-
tesy Press Association
Picture Desk (PAPD).
These courtroom
sketches were pub-
lished by BBC.com.
An initial query to
BBC News led us to
the PAPD, which had
the sketches on file
in JPEGs and identi-
fied the artist as Cook,
whom we contacted
via her website. Both
Cook and the PAPD
kindly waived fees for
one-time use in this
book.

only had to pay civil damages for breach of privacy but was also fined in criminal court.

Of course, I'm assuming you don't make a living crashing star parties or racing around on a motorcycle chasing princesses, and that your intention in publishing any image in your book or article is "serious." If so, and if you want to include photos of living people in your work, your publisher may require you to present releases from the subjects. What should such a release say? (See p. 68.)

Most important, you want to be sure that the subject of the photograph understands that the entire copyright to the work is yours, without restriction. If you do not need to pay or otherwise compensate the subject for taking the photograph, you may strike the first clause or write "none" as the description.

So, returning to the picture of the window shopper and her probable daughter; what did we do about it? In the end we decided to go

Date:

For compensation received [describe], I grant [your name], hereafter
referred to as "the photographer," permission to reproduce and/or exhibit
any photographs s/he makes of me in any way whatsoever, and in con-
junction with any other works worldwide. I agree that the photographer
and her/his licensees and assignees may use the photograph(s) described
above, either wholly or in part, in an institutional or commercial context. I
understand that I do not own the copyright of the photograph(s).

Model's name (printed):

Signature:

Address:

ahead and use it on the front of the book's dust jacket, even though
the author hadn't obtained releases from the subjects. But we treated
the image conservatively, screening it into the background. We ob-
scured the woman's face—though not the little girl's. Our attorney, a
self-proclaimed authority on child development, assured us that the
toddler would look entirely different in another six months when the
book was published and that no one would be able to recognize her.

* * *

Far touchier was the time we were to publish a portfolio of nude photography. In fact, to describe the images merely as *nudes* doesn't quite do them justice. Many recorded people actually engaged in sex or energetic foreplay. They were unusual, serious photographs, beautiful, but also provocative. In our—the publisher's—imagination, they were not pornographic, but we thought that some viewers might construe them as such.

The photographer had obtained releases from many of the subjects, but, alas, not from all of them, presenting a problem. What if the subjects had posed for the photographs knowing they might be exhibited in art galleries from time to time, but with no idea that their likeness might be widely and *continuously* disseminated via a book? What if they objected to seeing their most sensitive moments published literally cheek to cheek with images of other writhing couples? Maybe for them the photo shoot had been deeply personal—the photographer had characterized her project as a study of intimacy—and here they were laid bare for all the world to see in what might be interpreted as a veritable orgy.

In any event, however you parse it, we didn't have the releases we needed to be able to publish some of those images. Several of the subjects had disappeared without a trace. What were we to do?

When the photographer couldn't track down a subject, we put the image to an acid test: Was the subject's identity apparent? In other words, if the live subject and the photograph were presented together in a court of law, would a jury be able to tell with absolute certainty that the photograph was of that person? We spent several sessions in the chamber of our general counsel studying the images, with forensic appetite.

One photo captured a couple mounted in the old-style missionary position, shot from above. Looking at it, you could only see the man's back and, beneath him, a wedge of the woman's forehead and a bright blue eye peering anxiously up over her lover's shoulder, locking gazes with the camera. Well, plainly you couldn't establish with

any certainty the identity of the man. Ditto the sliver of face of his female partner, so that photograph was permitted in the book.

In other photos the subjects were yawning or biting each other. The features alter so drastically in a yawn, how could one possibly be certain whose face it was behind that great open maw? We spent a long time baring our teeth and yawning at each other as we considered the question. Ultimately, some photographs were allowed to remain in the portfolio and others had to go.

Since that episode, the photographer has drifted away from the human experience and retrained her lens on the common objects of still life. Dead roses . . . a half-eaten orange . . . a bit of toast . . . remnants of a repast but nary an eater in sight.

No harm, no risks.

A lesson.

One day I was racing around a corner in Chelsea trying to elude a mugger who seemed determined to have my camera, when I ducked into a warehouse and came upon a large black bear reared back on its hind legs and several people in white leotards dancing around it with hula hoops. Two of the dancers were smoking joints.

A perfect Kodak moment, one I couldn't resist. Besides, I was already clutching my camera. The flash popped and, suddenly, everything stopped. All was silence, save for the sound of a single hula hoop clattering to the floor.

One of the dancers advanced toward me and imperiously held out his hand. With the trace of a foreign accent, he demanded that I turn over my picture card.

He explained in a rather malignant tone that I had just intervened in what should have been an ephemeral experience. It was to have lacked the quality of duration or duplication, being neither ritual nor text. It was an experiment in pure sensation that I had, quite unbidden, fixed, immured in filthy bits, which, from the view of the participants, were agents of post-industrial, hypertechnic imperialism. My brutish act had reduced their experience to the pedestrian category of *performance*, a grave misnomer because in fact it was impossible to choreograph the bear. He explained how the event belonged to the participants (including the bear), not to me, and why the document I had produced was theirs, if it was anybody's. "Gimme ze camera," he said.

Intangibility and the impossibility of ownership is a critical issue these days, explored by all kinds of artists.

Who owned the copyright to the image? I was the one who had made it, but U.S. law states that anyone who fixes a live performance in a photograph or video without the consent of the performers will be treated by the courts as an infringer of copyright.

On the other hand, copyright only protects works that are fixed in a tangible medium.[1] If the dancers had been reciting lines from a script or performing a work of choreography (previously recorded via video, diagrams, or shorthand), that would have been one thing. But as the leader of the hula-hoopers explained, the event was meant to be ephemeral. I suppose it's conceivable that they could have come after me for trespassing or for invasion of privacy if I had held on to the tainted image and published it, but experts assure me the right to copy it (had it survived) would have been mine.

1. U.S. Code Title 17, sec. 101.

8 ＊ *Monks in Faraway Places, or Latin Lives!*

AS MUCH as I exult in whining about big museums, there are obvious advantages to dealing with them. The staff is organized, they know what they are about, and they can communicate in a range of modern languages. Now and then, though, one must leave snug harbor and venture forth into terra incognita in order to capture just the right image. The scholar's endeavor depends on it.

I'd like to be able to tell you that adventures in publishing carry editors to faraway places—and often they do—but transport is typically via fax machine or phone rather than chopper or jet. Yet, even bound to the desk, one does meet interesting people. Take, for example, my friend Brother Gregor. The occasion of our meeting involved a work by the Renaissance painter Antonello da Messina, an artist of great rarity, born in Sicily and trained in Naples, who, legend has it, may have introduced oil painting into mid-fifteenth-century Italian art. Antonello is renowned for his practice of building form with color rather than with line like his contemporaries. His chromatic values are subtle, rich, elusive; his paintings exquisite and exceedingly scarce.

At the time of this story, a rumor was afoot of a long-forgotten Antonello, a *Madonna and Child*, in the sparsely populated mountains above the Sicilian port of Messina. I learned of the painting from an author who had decided she simply could not *live* unless she had it in her book, which was not about Antonello per se, but, as she explained, the image would be relevant all the same not to mention a glorious coup if we could be the first to publish it. Anyway, the

more this author thought about it, the more convinced she became that the painting was crucial to her argument. No, she didn't have a photograph of it but was absolutely certain she had seen it once, years ago, on an excursion to Sicily. No, she didn't know of anyone else who had photographed it either. A photograph would have to be made. The painting was in a monastery, or had been—was it still?

A curious thing about Antonellos: as a rule, they do not reproduce well. Something about Antonello's technique—so fragile really: the obsessive artist spent hours hunkered over his mortar and pestle, grinding, grinding, mixing. And he would take his works through the painstaking process of interlayering with a fine brush: first, the thinnest film of egg tempera alternating with one of oil paint, and then another layer of tempera followed by oil, over and over, hundreds of times, until the painting achieved a depth of color and reflection that few have managed to duplicate. The result is an image that seems so lush in the flesh but melts to mud in most reproductions, in part because these inspirations in pigment are not always lighted properly when photographs are made of them.

The painting of interest was in a tiny hamlet hidden in the Monte Peloritani above Messina. Antonello had returned to Messina toward the end of his life and had completed what scholars believe were a number of overlooked works still hanging in remote churches throughout the region.

This would be difficult. As my dispirited assistant put it, "a genuine pain in the butt."

"Let's think of it as a challenge," I responded brightly, since the effort would fall upon her beleaguered shoulders rather than mine.

Days passed.

"Any progress?" I asked, peering out of my office at the assistant in her cubicle.

"I can't find a photograph through any of the usual sources," came the sour reply, then, added with a note of reprehension, "Please know that I'm doing my best."

I said, "Why not phone the monastery and talk to the prior?"— a remark that elicited a sigh from the assistant, but who, bless her heart, nonetheless dutifully tried.

"No answer," she announced.

"What time is it in Sicily?" I wondered, doing the math in my head. "Probably around five o'clock . . . time for vespers, yes?" What did I, a lapsed Episcopalian, know about vespers?

Assistant, being Roman Catholic, knew. She shook her head.

"Try again tomorrow," I encouraged her, "but earlier in the day, when the monks are open for business."

"You realize," she was quick to remind, "that I don't speak Italian, so maybe you should make the call . . ."

"If you insist," I replied, a bit petulant, but at the same time secretly flattered. She had appealed to my vanity, the clever girl. I like to tell myself I speak Italian, but in fact I know only a few words — just a little tourist lingo — and I am bad on the telephone in almost any language.

The next morning at eight o'clock, I sat regally poised at the telephone. I had scrawled a few key phrases in Italian on a notepad and some technical details too.

I dialed.

"Hall-o," came a voice on the other end of the phone.

"*Mi scusi,*" I began, and then plunged into the inevitable question: "*Parla inglese?* Do you speak English?"

"Eh?"

This wasn't going to be easy. I tried other languages.

"*¿Habla español?*"

"?"

"*Parlez-vous français?*"

"????" . . . Silence.

"*Sprechen sie Deutsche?*" Heaven forbid. I didn't *spreche* a word of *Deutsche* myself. Don't know why I even asked, to tell you the truth.

Click. The phone went dead.

I waited a minute to compose myself, then dialed again.

"*Mi scusi —*"

"*Rkt! Wg***$#%@@?!*"

Click. Dead again.

I stared at the phone.

"Jeez, what language was that?" asked the assistant, who had been listening to the aborted conversation from her extension. "There weren't any vowels. I've never heard anything like it."

"Me either," I confessed. "I'll try again later. Maybe somebody else will answer the phone."

Nobody else did.

But the voice, between calls, had hit upon a plan.

"*Veni, vidi, vici* . . ."

I summoned our classics editor, and without further ado, he and the voice in Sicily settled comfortably into Latin discourse. We learned that the voice was that of a Brother Gregor. Brother Gregor was a visiting Lithuanian curé who had been temporarily recruited to cover the monastery's phone until someone more linguistically versatile could be engaged.

It is not so easy to discuss photography and modern currencies in Latin, but we made do . . .

"*Madonna?*"

"*Madonna, aio.*"

"*Per* Antonello?"

"Eh? Ah, *aio.*"

In the end, Brother Gregor acknowledged that, yes, indeed, the monks possessed the rare Antonello. No, they didn't have a picture of it, but an appointment could be made to visit the holy painting. And if we wanted to photograph it, only a small donation would be required.

Good, I thought, because practically our entire illustration budget for the book would be exhausted hiring a photographer. (Silently I was berating myself for being such a softie when it came to this author.) Did Brother Gregor know of anyone local?

No? A pity. Then we would have to hire our own. Arrangements were made for a photographer we found through an agency in Palermo to travel to the site to photograph the *Madonna*. His journey, as it happened, was arduous and took several days: the road was so rutted and steep that the man had to travel the last ten kilometers or so on foot hauling his equipment uphill, piled on the back of an ass, and, unfortunately for us, he was being paid by the hour.

Commercial photographers usually insist on retaining copyright to their work, even when someone else has commissioned it; however, when I went to write the contract, I did my utmost to craft an airtight deal. I wanted to ensure that both the photograph and the

negative would be our exclusive property. Yes, by god, *we* would be the ones with the goods this time; for once, *we* would be in the enviable position of licensing an image to others for reproduction; and *we* and only we would determine what fee to charge.

In short, two could play at this game. In drawing up the paperwork, I had several options, and, after some thought, I decided to go with a work-for-hire agreement. In such an arrangement, the author of a work made for hire is the person or institution who does the actual "hiring." Normally, works for hire are prepared by employees of a firm, but if I crafted the agreement properly, the photographer might have no rights whatever in the work, particularly if I made it clear that the photograph would serve a specific purpose and was meant to supplement a larger work (the book, in this case).

I began to write:

Work-for-Hire Agreement
between
[the photographer]
and
[the publisher]

We mutually agree that the copyright to the photograph described in the purchase order attached to this Agreement will belong to the Publisher and that you hereby relinquish any and all claim to ownership rights in the work, a photograph of a painting titled *Madonna and Child*, by Antonello da Messina, located in the Capella di Santa . . .

I stopped, put down my pen.

Hmmm . . . should I really concern myself with the sticky matter of copyright? After all, I had always taken the position that reproduction photographs of two-dimensional artworks did not constitute creative work and thus were excluded from copyright protection. Perhaps I should simply avoid mentioning copyright altogether and, instead of issuing a work-for-hire agreement, which devolves from copyright law, style the instrument as a simple "all rights" contract, meaning it would specify that *all* rights to the work would belong to the Press, without actually naming them. Picking up my pen, I started again.

The Publisher commissions from you, for its exclusive use, photography, as described in the attached purchase order, of a *Madonna and Child*, attributed to Antonello da Messina, in . . .

My mind raced. I remembered that in an all-rights agreement, the photographer would be able to reclaim rights to the photo after thirty-five years, so on second thought, maybe it would be better to spell everything out plainly and in detail to prevent any misunderstanding. After all, we were spending a fortune to photograph that painting and were entitled to protect our investment, were we not? Think how much it was going to cost to rent that burro. In a sense, we were doing the world a service simply by *creating* the image and offering it for what would surely be a pittance compared with what it would cost others to photograph the painting themselves. Yes, and we were practically obligated to copyright our intellectual property for this was *certainly* a creative endeavor. Anyone could see that. What skill it would take to light the damn thing . . . hardly a job for an amateur. And then the photographer would have to set up the camera just so in that dark vault, select precisely the right lens and film. It took a certain—dare I utter it?—*artistry* to make such a picture.

On the other hand, didn't I have a moral obligation to—? My head began to spin.

I stood up. Enough! What drivel! Of course we would copyright the photo. Like the very institutions I love to decry, I began to figure the angles. I calculated that once the word got out about this work, it would be really big news. We could license the image to the *New York Times*, to *Apollo,* to *Burlington* magazine . . . everyone would want a copy. Maybe even *National Geographic* would want to publish it. I began to wonder if there might be a way to prevent others from photographing Antonello's long-lost masterpiece, even though, admittedly, it was in the public domain. Maybe we could convince the monks to post a sign at the entrance forbidding photography. And if we affixed a copyright mark to the photograph in the credit line, that meant we could prevent—or least discourage—others from copying it out of the book we were about to publish. My

brain worked harder. I would need to be sure to include in the photographer's agreement a clause that enjoined him from ever making another photograph of the Antonello—would an Italian court honor such an agreement? I had no idea . . . I'd have to find out . . .

A lot of bother? You bet. And the day the image arrived was one in which I finally had to confront my own dimwittedness. The color photograph I pulled from the padded envelope was no more an Antonello than a Picasso. The picture featured a great ham of a Madonna with two pasty white blobs of paint for hands and an unfortunate child seated on her broad lap whose eyes were set too far apart in his head. It had none of the delicacy that characterizes the paintings of Antonello. It was clearly the work of an untalented amateur, probably from the 1950s. When I showed it to the author, she paled.

That was many years ago and an expensive folly. Yet even today I use the image whenever I can, which isn't often because it's just so incredibly ugly. Still, I try. When other editors amble into my office to brainstorm about possible illustrations for dust jackets, I bring forth the ersatz masterpiece.

"Have you tried the Antonello?" I suggest, as if it were a wine. "It's very nice. Not to mention, excellent value for the money."

If they hesitate, I place the picture reverently in their hands.

"Anyway . . . here . . . it's Ours."

9 * *Fair Use*

WHAT IS fair use? It's a term that eludes easy definition because fair use is not a law but "an equitable rule of reason"[1] that allows someone to make limited use of copyrighted material without having permission to do so.

In this moment of expansive copyright, the doctrine of fair use is enjoying a renaissance because it is a last holdout in the law against absolute commodification. In addition, the Supreme Court has made it abundantly clear that fair use *is* the legal mechanism that balances intellectual property rights with freedom of expression.[2] So let's take time to reflect upon this all-important concept.

For all the juice in fair use, it is steeped in misunderstanding. Copyright owners fear that an extravagant culture of fair use will weaken intellectual property rights; however, fair use is not a denial of copyright. Rather, fair use says to the copyright holder, "I recognize that you possess certain rights in this work, and for very good reasons I'm going to use it anyway." In other words, copyright owners do not cede their rights in a work just because somebody else makes it the object of fair use.

Strictly speaking, fair use is an American doctrine. It is a balanced expression of goodwill among the members of U.S. society. There are those who say that fair use cannot be brought to bear upon sit-

1. See 1976 Copyright Act, sec. 107. Also see U.S. Title 17—Copyrights. Historical and Revision Notes, house report no. 94-1476.
2. *Eldred et al. v. Ashcroft* (01-618), 537 U.S. 186 (2003).

uations in which the copyright laws of other countries are implicated—for example, when a foreign work is published in the United States or when something made by a U.S. writer or artist is first published overseas. But as a practical matter and a legal one, too, Americans regularly employ fair use when it comes to the works of other parties to the Berne Convention since no member country is obligated to protect the work of foreign authors more than it does that of its own. The fair-use doctrine has proven to be such a powerful instrument that it is beginning to gain traction in other countries as they try to shake off the chill of rampant commodification. The Australians, for instance, are working to incorporate an American-style fair-use doctrine into their law.

Fair use's great strength—its fluidity—is also what provokes so much uncertainty. What is most important to understand is that *each case for fair use is unique and must be evaluated on its own facts.* There is no magic formula for what makes a case of fair use. Individual publishers have their own fair-use policies: one may say it is acceptable to quote 10 percent of a text for which it controls the rights while another may be willing to part with only a few sentences. But as to legal calculus, courts—not publishers, authors, or copyright holders—decide what constitutes an act of fair use, and courts do this case by case. At base is the question of whether, in using someone else's work to your own ends, you have *transformed* it to the extent that your work does not displace it in the marketplace.

The fair-use doctrine involves a set of four factors that American courts have developed, over the years, in weighing whether one party has infringed on another one's copyright by making limited use of a work without permission. These are as follows:

1. *The purpose and character of the use.* In using an artwork without permission, have you transformed it? Artists, for example, take and manipulate each other's work every day. It also matters whether the use is for a commercial or for a nonprofit, educational purpose.
2. *The nature of the copyrighted work.* Is the material being used factual or is it creative? In other words, taking facts first put forward

in a history book and using them in service of your own creative project may constitute a case of fair use. There would be stricter limits placed on the use of a poem or a painting.

3. *The amount and substantiality of the portion used in relation to the copyrighted work as a whole.* This factor actually has two dimensions: qualitative and quantitative. Qualitatively, a court would want to assess whether a new work takes unto itself "the heart" of the original work or whether that work has been sufficiently transformed. (We will soon examine litigation around this issue that involved the artist Jeff Koons.)

The quantitative dimension of fair use deals with—literally—what percentage of a copyrighted work has been appropriated for use in a new work. Now, with respect to *publishing* visual images: a quantitative approach seldom makes sense, for authors normally want to publish whole works. Rarely do they need to disarticulate, say, a brush stroke from a painting without also publishing the entire image. On the other hand, for movies or video—narrative works that evolve through time—this factor makes excellent sense, to the extent that the Society for Cinema Studies issued a position paper in 1993 identifying the capture and publication of individual film frames as a fair-use practice.[3] Even though big media companies discourage it, what is most intriguing is that none of the arts and entertainment attorneys I polled could name any actual litigation over this specific activity. Thus we see how, by taking a stand and focusing on fair use as a positive professional practice, scs has created what might be termed "an authoritative account of professional consensus about what's good practice and what isn't."[4]

3. I am not talking about the publicity photographs made on a film set. Those are a different matter, with their own legal implications. See "Fair Usage Publication of Film Stills," *Cinema Journal* 32 (1993).

4. For more on the scs statement and similar efforts by other professional organizations, visit the website of the Center for Social Media, June 2005, http://www.centerforsocialmedia.org/rock/finalreport.htm. The Center for Social Media receives support for some of its projects from the MacArthur and Rockefeller foundations.

4. *The effect of the use upon the potential market for or value of the copyrighted work.* By publishing or manipulating an artwork, or part of an artwork, are you undermining the market for it or depriving the copyright holder of income? This factor is at the core of many of the cases we are about to discuss, so let's get to it.

FAIR USE AND THE ARTIST

No artist works in a vacuum. Fair use is an elemental, creative tool. Michelangelo borrowed from Donatello. Rubens not only copied figures directly from Michelangelo's paintings; he did so without shame. Indeed, before the nineteenth century, it was considered a sign of enormous respect for one artist to copy another's work. For thousands of years that was how artists learned their craft.

Borrowing is more complicated in today's world, but a classic example of how fair use works can be seen in Rod Northcutt's beautifully executed birdhouses (fig. 18), which take as their object one of Donald Judd's sculptures (fig. 19).

As we've said, the test of whether an artist has fairly appropriated a copyrighted work hinges on the creative act being *transformative*. Northcutt has appropriated certain formal characteristics of Judd's piece, and his minimalist birdhouses constitute a playful, reflexive parody of Judd's more famous and emblematic work. What makes Northcutt's project a dynamic instance of fair use is that in no way does it compete with the market for Judd's art or foreclose the opportunity for Judd's Chinati Foundation to license derivative products.[5] In other words, it's no market substitute for Judd's work. Northcutt does *not* re-present Judd's sculpture in precise detail in a different medium. As an artist, that's a quick way to get into trouble.

5. One might contemplate the case of the *Erased de Kooning Drawing*, made by Robert Rauschenberg. While the "new" work certainly affected the market for the original drawing, this is not actually a case of fair use, for de Kooning gave his permission to Rauschenberg to deface the drawing. See "Sidebar: Artists' Moral Rights."

FIGURE 18. Rod Northcutt, *Nest Boxes for 7 Inquiline Bird Species* (2003). Wood. © Rod Northcutt. Photograph © Rod Northcutt. Image provided as a slide. Fee waived.

FIGURE 19. Donald Judd, *Untitled* (December 23, 1969). Copper, ten units with nine-inch intervals. Overall: 180 × 40 × 31 in. (457.2 × 101.6 × 78.7 cm). Solomon R. Guggenheim Museum, New York. Panza Collection, 1991 (91.3713). Art © Judd Foundation. Licensed by VAGA, New York, NY. Photograph by Prudence Cuming Associates Ltd. © The Solomon R. Guggenheim Foundation, New York. Image provided as a TIFF. Fees paid: copyright to Judd Foundation/VAGA, $130; use and copyright to the Guggenheim, $102.50.

Readers may recall a legal dispute in which Jeff Koons was sued for using a copyrighted photograph without permission as the basis for a series of four wood sculptures he fabricated titled *String of Puppies* (fig. 20). The photograph (titled *Puppies*) had been licensed by its maker, Art Rogers, for use on a novelty note card, which is how Koons had noticed it in the first place. In producing the sculptures, Koons and his assistants had copied the photo in detail. When Rogers sued Koons for copyright infringement, Koons defended his action as "fair use." He argued that his sculptures were a parody of the original photograph and that they constituted a critique of mass production. He moreover claimed fair use "because the photographer would never have considered making sculptures." All of this played out in—guess where?—our old stomping ground: the U.S. District Court for the Southern District of New York. The result this time was chilling.

As to Koons's assertion that his appropriation of Rogers's photograph constituted a viable instance of fair use, "the court disagreed, stating that it did not matter whether the photographer had considered making sculptures; what mattered was that a potential market for sculptures of the photograph existed."[6]

The court augmented its decision by rejecting Koons's claim that his sculptures qualified for fair use because they employed parody. Rogers's photograph already satirized mass production, and it was decided that Koons had not treated the image in such a way as to suggest that his sculptures actually parodied *it*.

While this observation surely sent a shudder through the ranks of artists whose idiom is appropriation, far more chilling was the court's determination that Koons's *String of Puppies* sculptures compromised the market "for the licensing of reproductions and derivative works of the original work [by Art Rogers] by decreasing demand for similar works."

6. *Rogers v. Koons*, 960 F.2d 301 (2d Cir. 1992). For an excellent commentary, see Peter Jaszi, "On the Author Effect: Contemporary Copyright and Collective Creativity," in *The Construction of Authorship: Textual Appropriation in Law and Literature*, ed. Martha Woodmansee and Peter Jaszi (Durham, NC: Duke University Press, 1994), 29–56.

FIGURE 20. Jeff Koons, *String of Puppies* (1988). Polychromed wood, 42 × 62 × 37 in. © Jeff Koons. For what portion of the image is Koons asserting copyright? JPEG file kindly provided by artist. Fee waived.

Koons may be the most famous visual artist to be caught up in the recent spate of lawsuits that test the limits of fair use, but he is hardly the only one. William Strong says, "Court after court has wrestled with the question of how much a parodist can appropriate from the original work. To draw too tight a boundary will foreclose the possibility of effective parody, but on the other hand parody cannot be an excuse for a free ride."[7]

Consider another test: John Sparagana's hand-manipulated "ruins" of advertisement pages ripped from stylish couture magazines such as *Vogue* and *Elle* (fig. 21). What makes these works intriguing with respect to fair use is the degree of transformation implied in

7. William S. Strong, *The Copyright Book*, 5th ed. (Cambridge, MA: MIT Press, 1999), 194. Another key case worth reading is *Campbell v. Acuff-Rose Music, Inc.* (92-1292), 510 U.S. 569 (1994).

FIGURE 21. John Sparagana, *Untitled*, from the Sleeping Beauty series (2005). © John Sparagana. Some courts might construe Sparagana's copyright in this image as "thin": a thin copyright subtracts from protection the unoriginal aspects of the work. According to an extraction analysis, what part of the work would actually be left? Slide kindly provided by artist. Fee waived.

making them and in unmaking the original works: involved are the operations of bending, crushing, massaging, and folding to break down the clay coat on the paper and reduce the image to a ghost. The effect is, literally, physically transformative. The referent encompasses not only the fashion picture but the actual paper page, its woven structure. Equally intriguing from the perspective of intellectual property law is that even though the advertisement photograph is copyrighted, it is commonly perceived as ephemeral in a way that documentary and fine-art photography are not.[8] These im-

8. Leaving aside the fact, fashion photographers frequently repackage their images as art. Irving Penn and Richard Avedon worked in and mixed both moves of

ages—like the magazines they inhabit—are made to be consumed, devoured by the eyes, and tossed aside. Today's fashion photo statement is tomorrow's recycling. Sparagana's operation is an elegant critique of high style.[9] His images are actors within an ambivalent register of dramatic appropriation that locates them in the same pictorial universe as that of Warhol, Rauschenberg, and Ruscha.[10]

Let it be said that those inspirited tricksters have had to endure their share of legal hassles. Warhol defended himself more than once against charges of copyright infringement. His *Brillo Boxes* (fig. 22), first exhibited at the Stable Gallery in 1964, unleashed the wrath of Jim Harvey, who had designed the original container in the 1950s and who accused Warhol of artistic "plagiarism." Rauschenberg grew so sick of copyright squabbles that he eventually abandoned the practice of exploiting the photography of others and started making his own photographs instead. One might argue that this pushed Rauschenberg to expand his skills. On the other hand, it also hampered his ability to make art in the way he wanted, thereby affecting his freedom of expression.[11]

But, anyway, just because an artist toys with somebody else's work doesn't mean he wants you toying with his. Note Sparagana's bold assertion of copyright in the caption for the fatigued magazine spread. Sparagana also makes large-format photographs of the fatigues and sells them as original art bearing his signature and copyright. Would his copyright claim hold up if tested in court? As of yet this hasn't happened, but—how to put it gently?—the night is young.

photography. And certainly there exists a tradition, especially in Europe, of advertising companies portraying themselves as artists working in commercial genres such as the thirty-second film. Thanks to Adrian Johns for this observation.

9. This particular work by Sparagana literally absorbs, or reduces, an advertisement sponsored by Prada.

10. See Tracey Topper Gonzalez, "Distinguishing the Derivative from the Transformative: Expanding Market-Based Inquiries in Fair Use Adjudications," *Cardozo Arts and Entertainment Journal* 21, no. 1 (2003).

11. Here we are in the fragile intersection of section 8 and First Amendment rights.

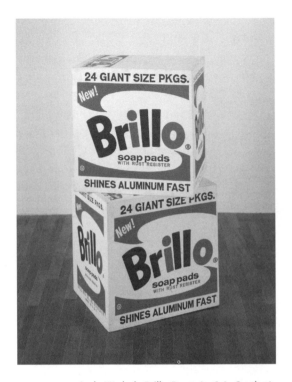

FIGURE 22. Andy Warhol, *Brillo Boxes* (1964). Synthetic polymer paint and silk-screen on wood, 17⅛ × 17 × 14 in. The Museum of Modern Art, New York, NY. © 2006 The Andy Warhol Foundation for the Visual Arts/ARS, New York. Digital image © The Museum of Modern Art/Licensed by SCALA/Art Resource, NY. Here again, ARS has put a 2006 copyright notice on a work that has been published numerous times since it was fabricated. Image provided as a JPEG. Fees paid: copyright to Warhol Foundation/ARS, $45; use and copyright to MoMA/Art Resource, $30.

An even tougher example comes out of artist Sherrie Levine's practice of photographing works by other artists and displaying the simulacrum as her own. Her point is to explore the status of artworks today and the minuscule amount of creativity required for a work to qualify as "original" in mass culture. For Levine, the test of originality is in the concept, the politics of display, and in the literary component of her work (the caption) rather than in the actual image. *Untitled (After Alexander Rodchenko: 11)* (fig. 23) is Levine's photograph of a photograph made by constructivist artist Alexander

Rodchenko in 1928.[12] Rodchenko's photograph is presently copyrighted in the name of his estate. Levine helped herself to the image, photographing it from an exhibition catalog. She changed the title, which for her is part of the work, and copyrighted the result in her own name.

An aesthetic value of appropriation is at the base of much contemporary art, and artists need relaxed fair-use standards. A number of proposals for expanding the doctrine are on the table. As Virginia Rutledge explains, "Responding to the high cost of defending fair use, and in the context of a shrinking public domain, a number of commentators have proposed . . . some form of compulsory licensing for works of visual art." One proposal, put forward by Judith Bresler, calls for the establishment of an art registry. In this system, "an artist would pay a set, floor amount for borrowing from a registered work of art—for a single use, one thousand dollars[!]. Upon selling

FIGURE 23. Sherrie Levine, *Untitled (After Alexander Rodchenko: 11)*, (1987). © Sherrie Levine. The caption just given is part of the work. Under the circumstances, may I publish Levine's work without obtaining permission, as an instance of fair use? By expanding the caption, am I creating my own unique artwork? If so, can I copyright it? Let's give it a shot. © 2006 Susan Bielstein. Image scanned from publication. Fee paid: $0.

12. Rodchenko's photograph is a portrait of the poet Sergei Tretyakov.

FIGURE 24. Woman passing in front of Lorna Simpson's *Wigs* (1994) on view at the Museum of Modern Art, New York City, 2005. © Kimberly Pence. Is this a case for fair use? Does the photograph critique Simpson's work? Image provided as a JPEG. Fee paid: $0.

her subsequent work, the artist would pay, in addition, a percentage of the revenue to the owner of the source image, who could also choose to be credited on the work and still retain copyright with respect to any third parties." As Rutledge points out, however, "this does not transfer well to the art world. . . . Say Damian Loeb paid for a license to borrow a registered image of Tina Barney's. Barney could still go after any other artist who used the image without paying, even if that third artist's source was the Loeb work, not Barney's. . . . Bresler's plan would require a license for any 'recognizable likeness.'"[13] Thus the proposal turns out to be utterly impractical since it refutes the transformative nature of fair use.

13. Virginia Rutledge, "Fare Use," *Bookforum*, April/May 2005, 33. For additional discussion of fair use, see also Rutledge's "Defining Fair Use in Visual Art Research Sources and Strategies," *Legal Reference Services Quarterly* 17, no. 4 (1999). Copies of the article are available for a fee from the Haworth Document Delivery Service: 1-800-342-9678, http://www.haworthpressinc.com.

FAIR USE AND EDUCATION

The fair-use doctrine allows slides and digital files to be employed for research and pedagogical purposes.[14] Fair use also applies to PhD dissertations that include illustrations because the raison d'être of the dissertation is educational. It is not within the purview of this book to deal with this area of fair use in detail; however, I should point out that allowances for education and research do *not* normally translate into publishing images, for publishing, even the non-profit variety, is not considered an educational enterprise. So, if you have obtained a slide for "research purposes only" and then decide you want to publish it, you may find yourself contractually obligated to go back to the provider for permission to do so, even if you are writing a highly specialized monograph.[15]

If readers will forgive a short rant, I have to say that, from the perspective of a scholarly editor, the commercial status of most non-profit publishing constitutes something of a categorical fallacy. The majority of university presses are ranked as academic—hence, educational—programs by their sponsoring institutions with oversight by the provost. And as demonstrated, university publishing, especially in the humanities, has long been a zero-sum game. Too bad that a cash exchange instantly disenfranchises this special branch of publishing from the kinds of unquestioned borrowing the law allows.

FAIR USE AND ART PUBLISHING

In a real courtroom in the real world, there exist numerous instances when fair use offers a perfectly valid defense for publishing artworks without copyright permission. However, some scholars invoke fair

14. These allowances are spelled out in the "Image Collection Guidelines" published by the Visual Resources Association, http://www.vraweb.org/copyright/guidelines.html. The Visual Resources Association describes itself as the international organization of image media professionals.

15. I should note that legal squabbles are starting to constellate around long-distance learning. The fact that it involves the transport and proliferation of images and texts via e-mail across long distances—for money—places it in a vague category somewhere between education and publication. For a summary of the TEACH

use to excuse their own laziness when it comes to pursuing permissions; others mock the doctrine by cherry-picking the parts of it that suit them and ignoring the rest. What we need to see are exemplary acts of fairness in every direction. Users cannot declare any convenient pillage "fair." For example, some authors any:

- "It's fair to mine a photograph from a magazine since one image is such a small percentage of the aggregate content." In fact, the "unit" for the purpose of analyzing fair use is the individual work (the photograph), not the "collective one" (the magazine). And a magazine usually does not control sublicenses to the illustrations anyway. Granted, in the sciences and social sciences, there exists ample legal precedent for taking photographs and charts and graphs from another publication if the image conveys precise *factual* data needed by an author to test his own hypothesis. Science, once published, is meant to enter the discourse rapidly. In contrast, the art world has far less tolerance for what might be viewed as the aggressive use of licensable *creative* property.

- "It's okay to publish a magazine cover without permission because it wraps the real content of the publication and offers a face to the world, bringing it virtually into the public domain." Sorry— magazine covers are protected by copyright, and their banner or masthead may be trademarked as well. This doesn't mean there might not be an occasion to publish that cover without permission, but it's not a given.

- "If I publish a work of art as a thumbnail, this qualifies as fair use." Thumbnails are a combustible topic right now, meaning they have been the subject of recent litigation. So be forewarned. In the minor ways of the courtroom, you might find that a judge or jury decides in favor of your fair-use defense, but in the process you will most certainly have jeopardized your relationship with what may be an important image source.

Act, passed in 2002 to expand educational exceptions to include distance instruction, see *Campus Copyright Rights and Responsibilities: A Basic Guide to Policy Considerations*, sponsored jointly by the Association of American Universities, the Association of American University Presses, the Association of Research Libraries, and the Association of American Publishers, sec. J (2005), 13–14.

In several recent cases, the court ruled in favor of a defendant who had published thumbnails and invoked fair use as a defense. Thumbnails were at the heart of the 2002–2003 lawsuit *Kelly v. Arriba Soft Corp.*[16] In that dispute, Leslie Kelly, a professional photographer, had found some of his photographs on a search engine operated by Arriba Soft without his permission. Kelly was suing the search-engine company for copyright infringement because, through links to other websites, Arriba Soft was displaying search results as thumbnail images. However, the court adjudged that because a thumbnail on Arriba Soft's search engine linked to an image in its primary context, the thumbnail didn't substitute for the original or undermine Kelly's ability to capitalize on his work, and rather more likely enhanced that ability.

Another instance: in 2005 the Bill Graham Archives sued the publisher Dorling Kindersley for including, without permission, some posters copyrighted by Bill Graham in a history of the Grateful Dead.[17] As it turns out, Dorling Kindersley had actually contacted the archive and offered to pay for permission to publish the images. Permission was denied—but DK published the posters anyway, as relatively small images. When the archive took Dorling Kindersley to court, the judge ruled in favor of the publisher, finding that the use did not compromise the market for the posters or derivative works (such as T-shirts, novelties, etc.).

But publishing *any* copyrighted image on a diminutive scale does not automatically a case for fair use make. As we've seen over and over throughout this book, it all depends on context. In the art world, you might be inviting trouble unless the thumbnail serves an indexical function: pointing the reader to a larger image for which rights have been properly secured.[18] In any event, if you want to use thumbnails in your publication—be it in print or

16. *Kelly v. Arriba Soft Corp.*, U.S. Court of the Ninth Circuit, U.S. District Court for the Central District of California, no. 00-55521. (Arriba Soft Corp. has since changed its name to Ditto.com.)

17. *Bill Graham Archives, LLC v. Dorling Kindersley Ltd.*, no. 03 CV 9507 (S.D.N.Y. May 12, 2005).

18. And some copyright holders will prohibit the use of thumbnails in any case.

online—you will most certainly want to discuss the matter with your editor.

- "I can copy an image without permission because mine is a work of *criticism*." While I sympathize with this view, most artists don't. They are apt to feel that publishing their work without authorization denies them the opportunity to capitalize on it. The College Art Association (CAA), however, takes a rather aggressive posture on the matter, suggesting that the fair-use doctrine ought to apply to any scholarly publication with a critical agenda.[19]

ORPHAN WORKS

How does fair use behave in relation to the actual market for images? Law professor Georgia Harper makes a compelling observation:

> Under [a] strictly economic analysis, in those circumstances where a ready market for permissions exists, such as permission for course-packs, fair use shrinks—perhaps in time as well as in other dimensions. But the opposite is true, too. Where the permissions market is dysfunctional, fair use expands, both in the amount one may use and in time.[20]

One area of the market where dysfunction runs riot is for the category of works known as "orphans." Orphans are works that are in copyright but whose authors cannot be traced: an uncredited photograph in a magazine, for instance, or an unsigned piece of deco jewelry. Traditionally orphan works have constituted prime occasions to exercise fair use, for, following Harper, if you don't know whom to approach for permission to publish a particular image, there exists no opportunity to ask permission and hence no market for it (the permission). But the past two decades have changed all that: the

19. Phyllis Pray Bober, "CAA Guidelines: Reproduction Rights in Scholarly and Educational Publishing," CAA, 2002, http://www.collegeart.org/caa/ethics/repo _rights.html.

20. Georgia K. Harper, "An Expert's Comment on Legal Responsibility," in "Visual Resource Image Collection Guidelines," VRA Committee on Intellectual Property Rights, www.vraweb.org/copyright/guidelines.html.

publication market has expanded for these stray materials as scholars' tastes have broadened to encompass all manner of visual and material culture. Today's art historian is just as likely to plow through a pile of old newspapers, snoop around a neighbor's garage, or sift for nuggets of arcana at flea markets as visit the vault of a famous museum. The intellectual market for orphan material is exploding, and thanks to the geniuses who crafted the 1976 Copyright Act and the Sonny Bono Copyright Extension Act of 1998, anonymous works are now protected for at least ninety-five years since publication or for 120 years since creation if they have never been published (and, as goes for other kinds of visual property, who would know?).

Alas, most of these objects exist in a perpetual limbo. The people who made them are unknown or dead or disinterested, and never would have dreamed that the doodad they whittled or knitted or scribbled was ever worth copyrighting in the first place.

Equally difficult to trace can be the material commissioned by a company that has long since folded its tent but whose copyrights survive intact, for ninety-five years. Tracking down legitimate claimants in these cases is time-consuming at best, but more commonly the trail goes cold.

If you have made a *good-faith effort* to find the copyright owner of an object, many publishers will allow you to publish it; *however*, publishers are deeply divided on exactly how much effort it takes to instill a sense of good faith.

In an increasingly litigious society, publishers hesitate to risk publishing images for which rights have not been punctiliously cleared. The CAA website is glutted with anecdotes of authors' unsuccessful attempts to locate copyright holders of obscure works and of their publishers' subsequent refusal to print the image. And even though authors are required to indemnify publishers against their mistakes, publishers know this doesn't stop aggrieved souls from crawling out of the woodwork and making a stink when they think a settlement will more likely be forthcoming from the publisher than from a junior author living paycheck to paycheck. The negative effects on the study of visual culture—not just by art historians but by anthropologists and sociologists too—have been most alarming.

FIGURE 25. An orphan reunited with its artist. I bought this modern work, *Sheep at Pond*, painted in the manner of Edward Hicks, at an antiques store in Taos, New Mexico. The signature on the painting is "Crowther." An Internet search for the name turned up nothing, so I telephoned the owner of the store, who, by happy accident, knew that the artist was a local man with the uncommon name "Satori." I Googled "Satori + Taos" and a single item was returned, which mentioned one "Satori Gregorakis" serving as the master of ceremonies at a local charity auction. A call to Directory Assistance in Taos turned up no such person, but because all of New Mexico shares the same area code, a Gregorakis did appear on the telephone grid for Albuquerque. So I called him. It turned out that Gregorakis is known for his renditions of primitivist paintings from the eighteenth and nineteenth centuries. Gregorakis never copies a work exactly, does not distress or artificially age the surface of his paintings, and always takes care to sign them with a bogus pseudonym so they will not be construed as forgeries. He agreed to my request to publish the work in this book. Painting © Satori Gregorakis. Photograph by Kimberly Pence (who does not assert copyright for the image). Gregorakis was paid a copyright fee of $25 and will receive a signed copy of this book. Image provided as a JPEG.

Here we are at the outer edge of the permissions imperium: which way does the compass point? What to do about all these orphans—how to establish a reliable mechanism for releasing them into the culture through publication without treading on toes—is all the talk right now.

In 2005 CAA joined other organizations, including museum groups, in responding to an initiative of the U.S. Copyright Office to study the problem of orphan works. Among other activities, these organizations supported a proposal by the Copyright Clearance Initiative of the Glushko-Samuelson Intellectual Property Law Clinic at American University's Washington College of Law that offers "a revision of the copyright law that would meet the needs and concerns of the widest range of copyright users and copyright owners . . . , create the least administrative bureaucracy, and set a good ethical standard."[21] The proposal seeks to limit remedies for copyright infringement if a work, after a reasonable search, appears to be truly orphaned. Writers, publishers, and museums would be protected from having to pay enormous fees and penalties if a claimant suddenly appears and asserts an interest in a copyright for an orphan.[22]

Other legal experts are urging courts to "deem it 'fair use' to copy an older work whose copyright owner hasn't taken reasonable steps to provide notice of his rights." Richard Posner wants to establish public registries where claimants can list "older works" in copyright. (One might ask, how old is "older"?) To many attorneys this plan seems retrograde, to come out of an earlier era, but it does speak to the practical fact that most things are intrinsically worthless from a monetary perspective.[23]

21. College Art Association, "'Orphan' Copyrights," http://www.collegeart.org/orphan-works.

22. "Orphan Works: Issues and Legislative Strategies," teleconference, May 2, 2005, sponsored by the Association of Research Libraries, American Association of Law Libraries, and the Medical Library Association.

23. Richard A. Posner, "*Eldred* and Fair Use," *Economists' Voice* 1, no. 1, article 3 (2004). See a more extended treatment of this proposal in Richard Posner and William Paltry, "Fair Use and Statutory Reform in the Wake of *Eldred*," *California Law Review* 92, no. 6 (December 2004): 1639–61.

In the end, the vigorous exercise of the fair-use doctrine is the only meaningful solution to the problem. It is time for professional organizations to take a stand on the fair-use treatment of orphans and what constitutes good practice. Doing so will encourage publishers to relax or at least revisit their guidelines in light of broader consensus.[24] As mentioned, the Supreme Court has stated that fair use is what reconciles the copyright system with First Amendment freedom of expression.[25] In delivering the opinion of the Court in *Eldred et al. v. Ashcroft*, Justice Ruth Ginsburg described fair use as a "traditional First Amendment safeguard."

The legal discourse of orphan works is momentously molten as I try to finalize this chapter (in February 2006). The Copyright Office has just issued its findings in a report that includes some preliminary recommendations on the treatment of orphan rights, particularly on the limitation of remedies.[26] Legislation will probably follow, but in the interim, what are authors to do?

Talk to your publishers. If they are reticent to publish orphans, encourage them to follow the debate and note the many groups pushing for more liberal interpretations of fair use.

In the meantime, stay on the orphan's trail. Admittedly, tracking the party responsible for that funky old psychedelic concert poster you fished out of the Dumpster can be utterly frustrating. Who knows who made it—let alone who now owns the copyright to it. But you still need to make an energetic effort to locate the copyright owner because current law says that anonymous works are protected by copyright for at least ninety-five years. (Various ins and outs of conducting a search for a rights owner are covered in chapter 10.)

Art in a Scene—De Minimis Use. When a work of art in copyright is just a small element of a scene, there is ample case law support-

24. Courts generally take a more liberal view of fair use when the orphan work has already been published, meaning its author intended it for public consumption predicated on an implied consent to the "reasonable and customary use" granted by article 1, section 8, of the Constitution.

25. *Eldred et al. v. Ashcroft*.

26. The Register of Copyright, *Report on Orphan Works*, January 2006, www.copyright.gov/orphan/orphan-report.pdf.

ing what is termed *de minimis* use, where the image is indistinct or fleeting. *De minimis* use is not the same as fair use, but it is convenient to bring it up here because courts have generally considered the fleeting appearance of an artwork in another work to be acceptable. But be aware that the artist may not think so. In 1996 Faith Ringgold sued Black Entertainment Television, Inc., and Home Box Office, Inc., for dressing the set of a motion picture with a poster of one of her story quilts.[27] The court found that the use of that poster was *de minimis* and in no way compromised the market for Ringgold's work.[28]

In a monograph published by one of my colleagues, the author, a distinguished anthropologist, wanted to include a photograph taken by his father. The old black-and-white snapshot shows the author as a diapered tot in front of the family home, squinting up into the camera. The author's thumb is in his mouth.

His father had said it was okay to publish the photo, so from a permissions angle everything seemed straightforward. We went to press, and about a year later, there came an irate letter from someone no one had ever heard of, complaining that we had published one of his sculptures without permission. Huh? This had to be a mistake.

The image was checked and, true enough, down in the lower right corner of the snapshot there appeared a small piece of yard art— a whirligig of some sort. None of us had noticed it—not even the author. The whirligig was not the subject of the photo; nor was it

27. *Ringgold v. Black Entertainment Television, Inc., Home Box Office, Inc.*, U.S. District Court for the Southern District of New York, September 23, 1996. The decision by S.D.N.Y. was upheld by the U.S. Court of Appeals for the Second Circuit, 1997. The artwork in question was *Church Picnic Story Quilt*, owned by the High Museum of Art in Atlanta. The museum held a nonexclusive license to reproduce the work as a poster and to sell those reproductions.

28. In a related case, *Sandoval v. New Line Cinema Corp.* (1998), the U.S. Court of Appeals for the Second Circuit also ruled in favor of the defendant (New Line Cinema), upholding the decision of the lower court, here again the U.S. District Court for the Southern District of New York (with Sidney H. Stein as the presiding judge). In that case the artist Jorge Antonio Sandoval filed for copyright infringement when the defendants used ten of his photographs fleetingly in the movie *Seven* without his permission.

mentioned in the book; it was simply one of a thousand minor elements in a scene . . . barely visible and hardly a Picasso. But, according to the artist, he was near to suicidal eclipse over the molestation of his precious whirligig. For him it didn't matter that we were well within the bounds of good practice in publishing the image. Even when we explained this to him (who, by the way, never produced any evidence that he had actually made the yard piece), and later, even when our attorney explained it to his attorney, he wouldn't desist. He threatened to sue us for punitive damages arising from the mental anguish he had suffered in seeing the whirligig published without his consent. An artist of the shakedown variety? Probably.

So what did we do? Did we call his bluff?

Hell, no. We paid him to disappear. Publishers want to avoid legal battles if at all possible, even silly ones they would most certainly win, like this one. Anyway, however silly this particular case was, it raises a serious point, which is that something has to give, and it will. In the arts there is no way around it. Either the intense grip of the permissions culture will start to relax or it will continue to tax an already frail field, and eventually art publishing as we know it will end.

But enough of lawsuits. By now you're probably thinking, "Get on with it already; what I need are specifics. As it happens, I actually do want to include a Picasso in my book. It's the painting *Les demoiselles d'Avignon*, from 1907, in the Museum of Modern Art. Since Picasso died in 1973, I know the painting is still in copyright, and I don't think my situation qualifies for fair use. I understand that, but now what do I do? How do I go about actually getting permission to publish it? And, by the way, how do I accomplish this without losing an arm and a leg?"

Keep reading.

10 ＊ *Doing and Saying Whatever It Takes in the Name of Scholarship*

CHEER UP. Chances are you *will* lose an arm or a leg but hopefully not both if you accept certain cold, hard facts about the permissions game.

Your mission is to publish an image. What do you need to do to get the job done?

First things first. If you don't need illustrations to make a point, don't use them. Concentrate on the writing. Make it every bit as lovely as you can. Every text deserves the chance to be a masterpiece. Chasing images is time-consuming and expensive. So if you can live without images, do it. Put that money toward orthodontia or a down payment on a house. At the very least, consider what my colleague Deborah Kirshman, at the University of California Press, says: "A book is not a slide show with dueling projectors."[1] Every image that goes into your book should be essential to the argument. Forswear gratuitous comparisons.

Once you have pared your illustration list accordingly, you are ready to consider certain questions.

What permissions do I need?

It's worth pausing here to repeat: *copyright* permission is usually tied to an artist and his lineage or to a corporate body that commissions

1. CAA-sponsored session on academic publishing, College Art Association annual conference, Seattle, WA, February 20, 2004.

specific works for hire; use permission comes from the person or institution who can furnish a reproducible image for you to *use*. (This may be the artist or the owner of the artwork, but very often it will be a commercial photo archive such as Art Resource or the Bridgeman Art Library.) If a work is in copyright, you certainly need the former; and if you are asking a content provider to send you a publishable reproduction, the latter is automatically included in the transaction. If a work is in the public domain, technically you don't need anyone's permission to publish *it*, but, depending on the source and character of the surrogate image, there *may* be some permissions involved.

COPYRIGHT

When is permission to use copyrighted material NOT required?

Almost every country allows you to use a reasonable amount of copyrighted material without asking permission of the copyright owner. In the United States, this practice is known as "fair use"; in Great Britain, it is called "fair dealing." Whether or not appropriating a work qualifies as fair use must be decided on a case-by-case basis, and it would be wrong to offer specific advice here. Chapter 9 of this book is dedicated to the nuances of fair use, so I recommend you start there and then discuss particulars with your publisher or an attorney.

Needless to say, for artists, fair use is an essential creative tool that allows them to produce derivative works. Devoid of fair use, there would not be a legitimate market for Paul McCarthy's inverted world of Disney-esque characters and Warhol could never have copyrighted his own versions of the famous Brillo box. This dimension of fair use is infinitely crucial to cultural production, but it is not immediately relevant to the subject of publishing artworks.

When is permission to reproduce artworks NOT required?

Permission is not needed if an artwork is in the public domain and you photograph it yourself. But there's often a catch: If you visit the British Museum and ask if you can photograph the Elgin Marbles,

they'll tell you that they allow flash photography in their galleries "for personal use only." Without coming right out and saying so, what they really mean is that the museum does *not* allow photography for *commercial* use, which includes publishing. For that, they want you to buy photographs from them. If you do publish one of your own photos in a book or article, will they come after you? Probably not: the British Museum has far bigger game to bag than you — but, as we saw in chapter 6, you never know. This is one of those matters with no simple solution.

Nor do you need permission to photograph two-dimensional works in the public domain from books, though this is a contested matter. Increasingly, editors of scholarly publications will accept images copied this way. With improvements in printing and scanning technology, often a photo-stand picture will suffice.

How do I know if an artwork is still in copyright?

This all-important question was introduced in chapter 4, and, as we've learned, there are sometimes gaps between the law and actual practice. The subject warrants a bit of practical discussion here.

If you live in the United States, the obvious way to determine if a work is still in copyright is to initiate a search with the U.S. Copyright Office. But as we know, for artwork, the result of such an investigation is rarely satisfactory. For many years there existed no way for artists to register their works, and even today few artists go to the trouble.

Be that as it may, you must attempt to sort it out. Determining if something is truly in copyright centers on two key pieces of information:

- the identity of the artist who made the work, including her name, death date, and nationality (the challenges of researching so-called orphan works are discussed in chapter 9 as well as later in this one)
- when the work was created and, if it is a work made by an American artist before 1978, whether or not it has been published, and if so, when

There are many ways to determine an artist's death date. With so much information at the digital tips of one's nimble fingers, this has become a simple task. The Copyright Office maintains an obituary index, though it doesn't list every artist. You might consult the Library of Congress website. Initiate a search for the artist of interest, and the server will return a complete list of his registered works in the collection, as well as his birth and death dates. Websites for the Bibliothèque nationale, the British Library, and other national libraries of deposit are equally knowing. Online, you can check the *Encyclopaedia Britannica* for famous artists, the *Grove Dictionary of Art*, or www.artcyclopedia.com. In print are any number of specialized handbooks.[2] And, of course, the Google search engine will lead you in useful directions too numerous to mention.

You need to know the artist's nationality in order to assess whether and where she is protected. The production of artists living in North Korea, for example, is not protected by other countries because North Korea is not a party to any of the international treaties that establish reciprocal copyright protection.

On the other hand, the exigencies of an expanding global market for books and journals make it increasingly important to take into account the copyright laws of an artist's home territory (as we've learned, most countries are moving toward a copyright term of the artist's life plus seventy years—for the People's Republic of China, the term is life plus fifty years). With the many diasporas of the twentieth century, the nationality of some modern artists is not

2. Harold Osborne, ed., *The Oxford Companion to Art* (Oxford: Clarendon Press, 1970); Erika Langmuir and Norbert Lynton, *The Yale Dictionary of Art and Artists* (New Haven, CT: Yale University Press, 2000); *The Thames and Hudson Dictionary of Art and Artists*, consulting editor Herbert Read, revised, expanded, and updated edition by Nikos Stangos (London: Thames and Hudson, 1994); Nancy Frazier, *The Penguin Concise Dictionary of Art History* (New York: Penguin Reference, 2000); *The Oxford Dictionary of Art*, ed. Ian Chilvers and Harold Osborne, consultant editor Dennis Farr (Oxford: Oxford University Press, 1988); John Fleming, Hugh Honour, and Nikolaus Pevsner, eds., *Penguin Dictionary of Architecture and Landscape Architecture*, 5th ed. (New York: Penguin Books, 1999); and Peter and Linda Murray, *Penguin Dictionary of Art and Artists*, 7th ed. (New York: Penguin, 1997).

so easy to pin down. Willem de Kooning produced art as a card-carrying citizen of both Holland and the United States. How does one establish the copyright status for his various productions?

You can worry yourself sick about it, or you can cut to the chase and contact one of the agencies that represent artists' rights, such as the Artists Rights Society (ARS) or the Visual Artists and Galleries Association (VAGA) in the United States, or the Design and Artists Copyright Society (DACS) in the United Kingdom. Many countries have an organization that represents its citizen artists. Together, these agencies constitute a syndicate known as the International Confederation of Societies of Authors and Composers, also known by its French acronym, CISAC.[3] The visual arts branch of CISAC is the International Council of Authors of Graphic, Plastic and Photographic Arts (CIAGP).[4] All the sister agencies have agreed to represent one another in their respective countries, so even if you seek to acquire a license for a work by a Peruvian artist registered with APSAV, if you live in the United States, you would do so via ARS. The rights of an artist who joins one agency are monitored and protected globally by all the members of the confederation.

Visit the website of any of these agencies and scroll through the roll call of artists represented. You'll find hundreds of Oh Great Ones listed, as well as thousands of lesser-knowns.

If you are interested in publishing the work of a living artist, you may discover he is represented, not by a rights agent, but by a dealer. For example, in the United States, the Marian Goodman Gallery in New York City handles requests to publish works by Gerhard

3. CISAC is a nonprofit organization headquartered in Paris. For more information about CISAC, visit their website at www.cisac.org.

4. In addition to the agencies already mentioned, members include ADAGP, France; AKKA/LAA, Latvia; APSAV, Peru; AUTORARTE, Venezuela; BONO, Norway; BUS, Sweden; COPY-DAN, Denmark; Creaimagen, Chile; EAU, Estonia; GESAP, Georgia; HUNGART, Hungary; JVACS, Japan; Kuvasto, Finland; LATGA-A, Lithuania; OSDEETE, Greece; ProLitteris, Switzerland; SABAM, Belgium; SACK, South Korea; SGA, Guine-Bissau; SIAE, Italy; SODRAC, Canada; SPA, Portugal; Stichting Beeldrecht, the Netherlands; VBK, Austria; VG Bild-Kunst, Germany; VEGAP, Spain; VISARTA, Romania; and VISCOPY, Australia.

Richter. And not every country has a rights agency: there is only one in Africa and two in Asia. This poses considerable difficulty for scholars, curators, and critics interested in the contemporary art scenes of these continents. Writing about them would be considerably bolstered if more countries would establish centralized rights agencies.

To be sure, many artists handle copyright-related matters themselves. Even so, if you are based in the United States, it saves time to start with the people at ARS. If they don't represent an artist, they will try to point you in the right direction. People who work at rights agencies may be extremely well versed in the minutiae of intellectual property law, but remember that they represent artists and estates. Their purpose is to manage commercial licenses and to generate income. While they may advise artists on the law, it is not their job to challenge the policies set by clients.

Example: if you want to write in any meaningful way about Picasso, you have to play ball with the Picasso heirs, and they control the game, every step. If you wish to publish the famous portrait of Picasso's dog *Kazbeck* (fig. 26) taken in Picasso's studio by the photographer Brassaï, you may find you are counseled to clear permissions not only with Brassaï's estate, but with Picasso's too.

One could wonder what portion of the copyright to this photograph might be owned by the Picassos, but the Administration doesn't debate technicalities. They don't need to; they are the Picassos—end of story. Or so they'd have us believe.

But sometimes it's okay to stand up to exaggerated claims, depending on your mettle. Remember those make-believe Picassos in *Surviving Picasso*, the Merchant Ivory film starring Anthony Hopkins? The Picasso Administration had denied Merchant Ivory permission to photograph authentic works by Picasso for inclusion in the movie, mainly, it seems, because they had initially tried—and failed—to block the making of the film, which painted an unflattering psychological portrait of the misanthropic artist. To make a film about an artist without showing his art would seem absurd to the point of impossibility, the Administration must have reasoned, but the film producers made it anyway, resorting to "half-finished

FIGURE 26. Brassaï, *Kazbeck*. © Estate Brassaï-RMN. © 2006 Estate of Pablo Picasso/Artists Rights Society (ARS), New York. Photo credit: Réunion des Musées Nationaux/Art Resource, NY. The Brassaï estate encouraged us to also clear rights with the Picasso Administration, and so ARS, which represents the Administration in the United States, has taken the opportunity to append their ubiquitous 2006 copyright notice. Image provided as a transparency. Fees paid: copyright to Brassaï Estate, $183.18; copyright to Picasso Administration/ARS, $60; use to RMN, $30.

look-alikes," as director James Ivory put it,[5] executed by others in the manner of Picasso. This prompted some major chest-thumping, but the movie producers were well within their legal rights, for one cannot copyright "style." Still, the Administration did not lose on all fronts: the case received extensive coverage by the press, and a litigious reputation can actually be a prized asset when it comes to discouraging future troublemakers.

What rights do I ask for? What other information do I need to clear copyright permission for an illustration?

It's a Great Big Beautiful World, and your publisher will want to sell your book into all of it. In order to do this, you will need to ask lenders for one-time ("one-off"), world-English, nonexclusive rights to the illustrations you wish to publish.

What does this mean? It means that you are requesting permission to publish an image in an English-language work only, to be issued by a particular publisher whom you must name, that can be sold worldwide. You are *not* asking to include the image in a translated edition of your work. And "nonexclusive" means you are *not* asking the artist to restrict use of the image by anyone else who wants to publish it.

It is important to get this right. A goof-up can have unfortunate consequences. Several years ago, I was on the verge of printing a heavily illustrated biography of Le Corbusier. Everything was perfect—too perfect. I just happened to thumb through the thick permissions file for the project, looking for one thing, when I came upon another thing that could have scuttled the whole of it. Out of 183 copyright permissions from the Fondation Le Corbusier, there was one license granting U.S. rights *only* for an image rather than world rights. A simple error, but one with potentially devastating consequences. Because of the restriction on this single illustration, we weren't legally entitled to sell the book beyond our own borders.

5. Merchant Ivory Productions, http://www.merchantivory.com/picasso.html.

Such glitches can usually be rectified, but had we distributed the book without expanding that license, the Fondation Le Corbusier would have been within their rights to charge us a fee to set things straight or to insist that we recall every copy of the book sent to foreign markets.

How much time does it take to acquire illustrations and permissions?

Many people have a touching belief that things will sort out as they should. Don't be deluded. If you are about to finish writing an art book and embark on the long, expensive process of acquiring the illustrations and the rights to publish them, you will need far more time and much more money than you think to get the job done. Raise every factor—time, money, labor—to the power of three and you are probably being realistic.

You will need six months at least if you are acquiring more than a handful of images and can't obtain them as general stock items from Art Resource or another commercial photo archive. And most publishers will want you to submit all the images and permissions for your book in a single batch rather than piecemeal. When you are thinking about working with a particular publisher, ask about their policy on this matter. Plan ahead.

Speaking of publishers, should I clear copyright permissions before I have one? Will publishers be more inclined to accept a book if the permissions work has been completed when I contact them?

Unless you are on cozy terms with the artist you are writing about, you won't be able to complete the permissions work until you actually have a publisher. One of the things an artist will want to know, in granting you limited rights to his work, is how the work will be used and for what purpose. This not only affects the decision to let you publish it but also the fee to be charged. If you wish to publish a Jasper Johns on a novelty tote bag, Mr. Johns probably won't allow it, but if he does, he will certainly recognize your venture for what it

is—a commercial rather than scholarly one—and will exact plenty for the privilege.

For a book or article, the right that Mr. Johns would grant you would be to publish one of his pieces in a specific work published in a specific edition by a specific publishing firm in a particular language, and he'll want to know who that publisher will be.

Returning to Picasso, the redoubtable Minotaur, let's join a scene in which a young American scholar is right this very moment spinning a crucial bit of discourse around *Les demoiselles d'Avignon*. His close reading of the painting was declared "bold and original" by his dissertation committee, and the paper he delivered at CAA last year drew a small but not unenthusiastic crowd.

Young Scholar is ambitious. He wants a full-page color reproduction of *Les demoiselles* to serve as the centerpiece of a book he is writing about artists who were misogynists. Including a full-page color view will add a touch of glamour to what is fundamentally a warmed-over dissertation. Assuming his publisher agrees with this plan, how does he go about clearing rights for it?

He will first need copyright clearance from the Picasso Administration, which is represented in the United States by ARS. He begins by sending a letter (via mail, fax, or e-mail) to ARS that describes his project and includes several key pieces of information. ARS will want to know:

- the title of the work he wishes to publish and the name of the artist
- the name of his publisher
- the print run of the publication—that is, how many copies will be printed for sale (get this information from your publisher)
- the territory where the publication will be distributed (United States, North America, or worldwide)
- whether the publication will be published in English only or in other languages
- whether the image will be reproduced in color or in black-and-white (color triggers the luxury factor)

- the size at which the image will be reproduced (one-quarter page, half page, three-quarters page, full page—licensors figure the bigger the image, the more commercial the work)
- where the image will appear in the publication (in the book's interior or on its cover, which is more expensive because it is viewed as a form of advertising)

The licensor will want all this information in calculating how much to charge you for that image. Above all, do not brag about the assured success of your book. Success means sales, which means more money, which means bigger fees. Restrain yourself. A little false modesty goes a long way.

Take a look at Young Scholar's letter to the Artist Rights Society requesting copyright clearance for the Picasso (p. 112).

ARS may decide to consult the Picasso Administration about the request, but usually licenses are issued on the basis of a fee schedule and a set of restrictions already supplied by the estate. Once the Young Scholar's request has been evaluated and approved, ARS will send him a letter granting permission to reproduce the work. (He should make a copy of the letter for his records and put the original in a file to send to the publisher as proof of duty done.) The lender will issue a combination invoice/authorization outlining the terms of the permission and any applicable fees. The form will also provide a copyright credit line that must accompany the image. And the bill for a full-page image in color in a scholarly monograph: $135.[7] Not so dreadful, but it doesn't account for what Young Scholar will have to cough up to rent a reproduction-quality image of the painting, which will amount to many more dollars. Plus, there are at least a hundred other images to gather . . . Young Scholar can feel the singe of crisp twenties immolating in his pocket. Maybe the book of his dreams could survive without this particular vision in color. After all, the ladies have been printed in glorious pinks and greens many times over—by luckier and richer authors.

7. Based on a fee quote from ARS, May 4, 2005.

How do I keep track of the myriad details associated with rights licenses?

At this point, before taking another step, you need to have a good, hard think about how you are going to manage the paperwork that is already starting to mount up.

Artists Rights Society
536 Broadway, 5th floor
New York, NY 10012

Dear Artists Rights Society:

In fall 2006, Blankety-Blank Press will publish my book *Misogyny and Art: A Pan-Gendered History of Artists Who Hate Women*. I want to include Pablo Picasso's painting *Les demoiselles d'Avignon* (1907), in the collection of the Museum of Modern Art in New York City, as an illustration.

I am requesting one-time, nonexclusive world-English rights to the work, which will be reproduced in color in the book's interior as a full page.[6]

Blankety-Blank Press will print 1,400 copies of this scholarly monograph. Please let me know as soon as you can if I may include this work in the publication as well as what fee, if any, is required.

Sincerely yours,

Young Scholar

6. If you want to publish an artwork as a full page, be prepared to do some explaining. Many estates forbid cropping of artworks, be it ever so slight, so if the publisher is planning to "bleed" the image off the page, you need to say so. Either you will be charged extra for the privilege or your request may be declined.

The entire process will be less odious, less confusing, and, yes, even less costly if you will organize yourself at once and start what we in the trade term a "permissions summary and art information log." This will help you choreograph the complex flutter of paperwork between you and the lenders and copyright holders. A summary log should capture all the legal and technical information relevant to publishing an illustration. It will include

- caption information
- status for copyright and use permissions
- coverage for language and editions
- fees
- image format
- special lender requirements

A sample log is included in the back of this book.

Wanted: Artists Dead or Alive?

As mentioned, if you want to publish the work of a living artist, you may find yourself writing to him directly or to his dealer rather than to an agency like ARS.

In considering your request, artists may, out of idle curiosity or paranoia, want additional information about the project. Some academics suffer from the naive belief that artists are eager to be included in a respectable scholarly study, grouped into the distinguished company of Picasso and Rembrandt, but most artists, especially famous ones, care not a whit for such fellowship; they've already made it into somebody's canon. It's more likely they'll want to know if you intend to trash them. You'd be amazed how sensitive even the very bad boys of art can be. So, you may first want to pause and consider exactly what you're doing before you shoot off a letter. Does the artist have a reputation for being difficult? Has he recently been skewered by the press? You might also want to clear a little advance ground by placing a call to his dealer. Here's where all your powers of charm and persuasion come into play, and, assuming

the dealer is receptive to your request, you should follow up the conversation with a letter immediately:[8]

As I mentioned on the phone to you this afternoon, I am hoping to reprint in color Artist X's *Embalmed Abomination of a Woman*, in the collection of the Museum of Modern Anatomy. This would appear as the closing image of over 180 reproductions in a nonprofit academic book called *Misogyny and Art*, from Blankety-Blank Press, print run of 1,400, world rights in English requested, to be published in 2006.

My study tracks the long tradition of rendering the female figure abjectly positioned in subjugation to the viewer from the Aurora Painter (fourth century BCE) on through Titian and Goya to the impressionists, and then beyond Picasso's atavistic women, and after them Weegee's night-fright photographs of painted old crones, into the excluded human figure of conceptual word art, all culminating in the brilliant return of the dissected body in Artist X's work. So you can see how very much I would hope to get the artist's permission for this climactic use!

Indeed, cost permitting, I am such an admirer of the work that I am hoping that we might be able to afford including it in color.

Would you kindly pass this request on to Artist X for his copyright permission—and thank him for me, many times over, if he is kind enough to grant it?

I much appreciate your help so far, and for further expediting this request.

Yours sincerely,

Young Scholar

This letter took some effort to craft, but the payoff was worth it: immediate approval from a publicity-shy artist at a bargain-basement copyright fee of $50 for the image in color, plus the loan of a transparency—free.

8. Thanks to Garrett Stewart for allowing me to revise one of his letters extensively for my own purpose.

If an artist wants to read your manuscript before granting permission to reproduce one of his works, avoid sending it if you can. See first if a solicitous letter will do the trick. Explain that you are a scholar writing a serious work and that you have no intention of besmirching his reputation (unless you do, of course). If you have written about him before, tell him where he can locate your article or attach a copy to the letter. In a few straightforward sentences, spell out the primary points of your thesis and how his work bears on your argument. Keep it brief. Do not go into a lot of needless detail, and if you have a penchant for jargon, by no means is this the time to indulge it. Very often a good letter will alleviate an artist's concerns . . . but not always. And it can be even harder to mollify an estate.

I've heard about the daughter of a famous artist who apparently delights in spitting on anybody who has ever written a negative word about her father. More than one close observer has watched her stalk an offender for blocks and even into the New York subway system in order to get off a shot. For the critic Harold Rosenberg, there existed no greater force to control an artist's reputation and to manipulate the market for his work than the singular towering figure of the art widow:

> The widow is identified with the painter's person, but she is also an owner of his art properties—in the structure of the Establishment widows stand part way between artists and patron-collectors. Commonly, the widow controls the entirety of her dead husband's unsold productions: this enables her to affect prices by the rate at which she releases his work on the market, to assist or sabotage retrospective exhibitions, to grant or withhold documents or rights of reproduction needed by publishers and authors. . . . The result is that she is courted and her views heeded by dealers, collectors, curators, historians, publishers, to say nothing of lawyers and tax specialists. It is hard to think of anyone in the Establishment who exceeds the widow in the number of powers concentrated in the hands of a single person.[9]

9. Harold Rosenberg, "The Art Establishment," *Esquire*, January 1965. See Magda Salvesen and Diane Cousineau, eds. *Artists' Estates: Reputations in Trust* (Newark, NJ: Rutgers University Press, 2005).

Rosenberg took a deeply cynical view of such dames and especially of Lee Krasner, the widow of Jackson Pollock. He made little allowance for the ceaseless stream of requests that she had to deal with every day. If art widows and executors sometimes come across as being tough or suspicious, it's no wonder. For every legitimate request that arrives through the mail slot or over the fax machine, there may be dozens that, from a widow's standpoint, seem inappropriate, damaging, or just too plain silly to warrant consideration.

What if they say no?

Until now our discussion has loped along on the sunny assumption that if you approach a rights owner courteously and with a modicum of patience, permission to publish a cherished artwork will eventually be granted. But what if the copyright holder says no—and means it? What then? For authors it can be maddening to see the promiscuous, smug object gazing out at them with a twinkle from other books and websites galore, like a thousand identical little stars in the aesthetic firmament—when a short session with a copy stand or high-resolution digital scanner could produce a copy of sufficient quality for publication.

Artists and trusts have their own ideas about things, and some of those ideas can be highly quixotic. I have seen permission to publish an image withheld for some very odd reasons indeed:

"A painting on canvas should never be published on paper."

"No way that shit is mine."

"I'm sorry. The picture you ask after carries a curse."

One estate threatened to withhold permission to utilize a crucial image unless the author deleted the word "surrealist" from the phrase "heir to surrealist René Magritte . . ." Obviously, authors have to pick their battles, and in this particular instance the author decided nothing of consequence was lost by agreeing to the change. "How firm do you think I stood?" he challenged me.

"Firm as the Spartans at Thermopylae?"

"Nope, I caved at once."

Of course, one can usually lead the reader somewhere else to view

a work, but what if an image has never been published and your argument hinges on making it available?

Once, the widow of an obscure Latvian architect wrote to explain that she could not possibly allow the University of Chicago Press to publish one of her late husband's drawings, for political reasons. During World War II, the house of her father had been burned to the ground by Polish mercenaries, and it was her understanding that Chicago was a city swarming with Poles. Was it not possible, then—no!—probable that some of those thugs, or at least some of their children or grandchildren, now lived here? Which was to say we could go to hell and she would go to her coffin before she would *ever* let us publish the work of her poor dear husband.

Sometimes "no" means "no."

But for the resourceful author, there are almost always alternatives.

We once had the occasion to publish an author who had decided to scrutinize the subject of modern marriage through a psychoanalytic lens trained on Georgia O'Keeffe's union with Alfred Stieglitz. Several books already existed about this unorthodox partnership, but they were characterized by a lot of throat clearing and tiptoeing gingerly around its margins, for there was and still is a highly energetic glee club surrounding Miss O'Keeffe that is determined to protect the icon's image. Now, deploying the sharp bore of psychoanalysis, our author wanted to drill through the artist's babushka and peer into her skull.

I was intrigued. Besides, O'Keeffe . . . bound to sell . . . $$$$.

Dollar signs danced before my eyes.

Silly me. What I didn't fathom was that those tiny $$$'s represented bundles of dollars waltzing out the door. The vision also prophesied a rather bizarre encounter with the designated enforcers of the O'Keeffe "will," which, as one of them explained on the phone, was not to be confused with the legal document.

Among the images slated for the book were several Stieglitz photographs that captured Miss O'Keeffe in the buff. One of the photographs displayed her displaying, in turn, a comely breast for the camera (fig. 27). Granted, the image might have been scandalous in

FIGURE 27. Alfred Stieglitz, *Georgia O'Keeffe: A Portrait*. Palladium print. The John Paul Getty Museum, Los Angeles (93.XM.25.53). © Estate of Georgia O'Keeffe. Though the photographic image is copyrighted in the name of O'Keeffe's estate, the Getty possesses the right to license this particular print for publication. Image provided as a TIFF file by the Getty, which collected a copyright fee of $82.50. How the Getty will distribute that fee is unknown.

its day, but by the end of the twentieth century, it had been widely disseminated and was part of the standard O'Keeffe/Stieglitz lore. Weeks passed and then months, as we waited to hear from the artist's estate if we could publish the photograph.

"How much longer?" I asked one of Miss O'Keeffe's executors. "Listen, I have a book to publish, and the paper we've ordered isn't getting any whiter."

There followed such a dead silence on the line that at first I wondered if the executor had simply gone away.

But then the pause ended as she told me of a mysterious figure known as "the third party."

"We can't do anything," she explained, "without the authorization of the third party."

"Third party?" I wondered aloud. "Who is this third party? Listen, just give me the phone number and I'll call up this person myself."

"*No-oo-ooo no-oo, no*," I was told. Not a good idea.

And so, for six months, permission hung in the balance as the mysterious "third party" deliberated, pondered . . . Yes? No? Maybe? In the end, permission for that image was denied, without explanation. But by then it no longer mattered: we had already acted on a tip that the Getty Museum owned a print of that particular Stieglitz photograph and was in a position to license it to us. Apparently the Getty had purchased it from the O'Keeffe Estate with a blanket grant allowing them to offer it for publication to whomever they pleased, even though it still carried the copyright notice of O'Keeffe's estate. So, thanks to the good offices of the Getty, we managed to include an image that had actually been refused by the estate. Nevertheless, this little bamboozle wound up delaying the book.

If you are seeking permission from an artist or estate to publish a work that is still in copyright and are told no, you may not be entirely out of luck. One of the most interesting angles of fair use centers on this very situation, where an artist refuses permission to publish one of his works. Depending on the use and whether it is meaningfully transformative—which we've learned is all-important to fair use— you *may* be able to publish the image anyway. Case law seems to suggest this: for example, in 1994 the copyright holders of the song "Oh, Pretty Woman" sued 2 Live Crew for infringement when the rap group wrote and published (on records, tapes, and CDs) a parody of the work. 2 Live Crew had actually requested permission from Acuff-Rose Music to make use of the song, and they had offered to pay a fee and to credit ownership and authorship of the original rock ballad to the music company and to Roy Orbison and William Dees, who wrote it. They also sent the company a copy of the lyrics and a recording of their own version. Acuff-Rose sued for infringement,

and the case went through several rounds of litigation and appeals, but ultimately the U.S. Supreme Court ruled in favor of 2 Live Crew, declaring their song an obvious instance of parody.[10] Of course, I'm citing a case from the fast lane of high-stakes entertainment law, not from the more stately byways of academe. Which is to state the obvious: if you decide to go ahead and publish a work in the face of a "no," you risk a lawsuit, not to mention jeopardizing future relations with the artist or her estate.

And then there is the matter of your publisher's timidity to overcome: human spirit notwithstanding, where there is a will, there is not always a way.

Can the owner of a work in the public domain prevent me from publishing it?

No, not if you possess a usable reproduction. The owner can, of course, decide not to do business with you in the future. They can refuse to do business with anyone.

What am I supposed to do about orphan works? What if I can't locate a rights owner?

In gentler times, many publishers were willing to publish an orphan work if you could demonstrate that you had tried *in good faith* to identify and contact a copyright owner. In today's litigious society, however, presses are almost equally divided on the subject. Some allow orphans to creep into a publication if you can prove you really did try to locate a copyright holder. Others don't. Should your argument hinge on being able to publish an orphan work, you need to discuss it with your publisher before signing a contract.

More liberal presses may allow you to publish an orphan in a book's interior (though not on the cover) if you demonstrate you have conducted an energetic search for the author. Such an investigation often starts at the U.S. Copyright Office, and it should involve

10. *Campbell v. Acuff-Rose Music, Inc.* (92-1292), 510 U.S. 569 (1994).

at least two attempts to locate a rights owner. This might amount to a notice in the classified section of a newspaper or a letter from a dealer or special collections librarian indicating that the author of the work in question is unknown.

In trying to track down heirs of a company or a publication that has gone out of business, you'll need to produce evidence that you have searched relevant probate records or corresponded with at least two sources, such as the federal tax office, a local chamber of commerce, professional organizations, or historical associations.

If you do manage to locate an heir, try to contact him by fax or by letter to ask permission to publish the work in question. If the heir doesn't respond to your first query, many publishers will advise you to send a second one that includes some language such as the following:

> This is my second attempt to contact you to request permission to publish a color photograph of the glass vessel described herein and confirmation that you are the legal claimant to this work. If I do not hear from you within three weeks, I shall take it as meaning that you do have the right to make this grant and that you approve my request to publish the work without restriction or fee.

Granted, it's a nuisance to do this when you know the response will likely be silence, but it's the cost of doing business today. As conveyed in chapter 9, this area of the law is very much in play.

Do publishers ever pay for illustrations and the licenses to publish them?

You can ask an editor to pay for your illustrations, but don't expect her to say yes. And just because she refuses doesn't mean she's cheap; it means she's done the math. A book may be groundbreaking, but if it is likely to sell fewer than five thousand copies, then, from a publishing perspective, it is groundbreaking in a hairsplitting way, making it implausible for a publisher to shoulder even a fraction of the cost of images and permissions.

If it seems that publishers are galloping toward prosperity on the backs of their authors, please consider this: We toil in the mire, too,

alongside our authors. We review their permissions work, mediate difficulties with lenders, evaluate digital files, sometimes help them scrounge grant money to pay for licenses, and move hundreds of images safely between lenders, authors, editors, printers, and, yes, occasionally even emerge from our bog to help an author hunt for images.

Very, very rarely, once in a while, a publishing house will research and pay for images itself. This is standard practice if a museum publisher is preparing an exhibition catalog, if a commercial publisher is producing a coffee-table book or textbook that may go on to sell many thousands of copies, or if a scholarly publisher wants to translate an art book from another language. Remember that illustration licenses are *restrictive* in character and are issued for a specific edition to be published by a specific press in a specific language. Foreign publishers can usually only sell rights to the text.

No wonder so few art books are translated into other languages — an insight you should bear in mind apropos of your own. Try not to shame your publisher if Flammarion doesn't clamor to translate your book about Jesuit style. Between the diminishing marketplace and the increasing costs of acquiring illustrations — not to mention soaring translation fees — it is the rare art book, indeed, that is published in a foreign edition. Nevertheless, in spite of the odds, it happens, and publishers can often provide film or digital files of the illustrations to one another. But even then, the *permissions* must be cleared anew.

USE: OBTAINING THE IMAGE REPRODUCTION AND THE PERMISSION TO USE IT

When someone supplies you with a tangible surrogate image of an artwork to publish in your book or article — a slide, for example — the permission to *use* it is implicit.

Use permission comes with restrictions that will be spelled out in the invoice agreement a vendor sends you. The vendor may designate that a slide is for one-time use or that no cropping of the image

is allowed, but this has nothing to do with copyright, though some vendors try to link the two by assessing a so-called repro fee on top of the fee to borrow or buy a copy of the artwork.

Agents such as ARS can help you clear copyright permissions, but they are not in the business of supplying reproduction-quality images. That's a separate task. The agent or artist's estate may be able to refer you to an appropriate source. Many agents are associated with fine-arts photo banks whose business it is to supply images to users. ARS, case in point, shares attractive loft-style offices with the company known as Art Resource. (Both firms are owned by Theodore Feder.) Art Resource is great for one-stop shopping. Think of it as a department store. Like Bloomingdale's, Art Resource doesn't carry everything, but you'll find most of the basics in its well-stocked archive and at reasonable prices if you are writing a scholarly book. Art Resource also serves as the clearinghouse for a growing number of museum collections and commercial "photo farms" in other countries. They are now the exclusive agents for Erich Lessing Culture and Fine Arts Archives, Alinari (headquartered in Italy), as well the London Tate and the Museum of Modern Art, which outsourced its permissions work to them several years ago.

In addition to Art Resource, other major image banks are the Bridgeman Art Library and Getty Images. Contact information for these and other sources is listed at the end of the book.

For works in copyright, should I clear copyright permission before obtaining a reproduction and the permission to use it?

Yes. If the artist or his estate refuses you the right to publish an image, there is no point in obtaining a reproduction. Most photo archives, museums, galleries, and other owners will require proof that copyright permission has been granted before sending a repro copy anyway.

Once you contact a photo archive, a museum, or some other owner of the work, they will send you a price list for the various formats in which they can supply the image you want to publish.

Assuming the copyright holder of a work has given me clearance to publish it, if I then go take a picture of the work in a museum that restricts photography, may I use my own photograph?

Time to return to that young, financially challenged scholar writing about artists who hate women. He still has *Les demoiselles* on the brain and is stewing over how expensive it would be to publish the painting in color. The copyright fee for the Picasso Administration is one thing; the fee to obtain a digital file from the Museum of Modern Art is another, and just as steep. The total cost of wish fulfillment? Nearly $300.

Refusing to be deterred, Young Scholar arrives at MoMA with a borrowed Nikon dangling from his neck, purchases an admission ticket, walks through the turnstile, travels to the top floor, where the painting now hangs, and sets up to photograph it.

The instant he trips the shutter, there comes a flash from the camera and a shout from a guard, who, striding toward him, yells out, "Hey, mister, no flash photographs in the museum."

All around him people are stretching their necks to stare. His own neck reddens with embarrassment as he dutifully fumbles to put the lens cap back on the camera and swears humbly before the guard, upon his mother's life, not to do it again.

But he did take the one photograph. And, later, after he goes home and uploads it onto his computer, it turns out to be rather good, if he says so himself. A deep smile of satisfaction spreads across his face. The realization dawns that he is happier than he has been in months, ever since he started this whole miserable permissions process. He took the picture; he made it; it's his. He decides it should go into the book. Triumphantly he writes the Picasso Administration (via ARS) to clear rights to publish *Les demoiselles*. He presents his own photo to his editor along with the permission letter from ARS, and that's the end of that. Or is it?

The next day his editor calls to say she is rejecting the image.

"But why?"

The editor explains that while the photograph might be fine for some uses, it is not adequate to the task of rendering a full-page in

color of Picasso's well-known masterwork. So ... flaunting museum photo restrictions isn't always the answer to your prayers, though a number of publishers allow authors to submit images from just about any source as long as appropriate copyright permissions have been cleared and the quality of the reproduction is sufficient for publication.

What kind of reproduction do I want?

Publishers will accept a picture in three basic formats: as a transparency or slide, as a high-resolution digital file, or as a photographic print. No matter the format, the publisher will have to arrange for the image to be scanned by either a professional scanning company or a printer to produce a file precisely calibrated to the printer's equipment. Illustrated books and paper journals ("analog" media) are still largely being produced using a method known as *offset* printing. Offset printing is a form of lithography, a technology that is more than two hundred years old.

Your expectations for how a beloved image will appear printed in your book should be based on the quality of the reproduction you provide the publisher. Any image degrades from one generation to the next. It's a fact of life and impossible to avoid, even in this hyper-tech age.

Be sure to ask your publisher for precise format specifications before you start ordering images. Each format has its pros and cons.

TRANSPARENCIES

For years transparencies have been—and remain—the preferred format of publishers. A transparency is a stable material not subject to the limitations of digital files. It is easy for the publisher to judge color accuracy against a match print. Even better, like the *Hodigitria*, the icon of the Holy Mother and Child that St. Luke is alleged to have painted directly from life, a transparency is only one generation removed from the original divine work of art. It is a direct photographic positive and does not involve the intermediate

generation of a negative. It is as close to an original as a reproduction can be.

Transparency Size. Transparencies come in a variety of formats. The most common is the 35 mm slide, but transparencies can be of almost any size: 4 × 5 inches, 5 × 7 inches, or larger. The larger the transparency, the more detail captured in the image. A slide can often be purchased outright and at reasonable cost, but due to its small size, a slide cannot be enlarged significantly without the image becoming blurry.

Suppliers of large-format color transparencies (usually 4 × 5 inches or larger) rarely sell them to authors but instead "rent" them for a limited period, usually three months, which, ingeniously, is hardly ever time enough to get the job done. So, if you rent a transparency, be prepared to return to the supplier to request an extension, which of course costs more money.

License extensions are a nuisance, though the reason for them is fairly motivated. Transparencies are expensive to make. One camera setup and shutter click yields one transparency, not a negative from which countless duplicates can be made. Thus a museum generally has only a limited number of transparencies to circulate. Other scholars and publishers may very well need to use that transparency for their own work. And institutions would rather circulate images on a rotating basis than have to commission additional transparencies. Of course, large institutions usually possess multiple transparencies of their works most in vogue, and herein lie both convenience and peril. Each transparency constitutes a unique image with slightly different characteristics from the next one, even though the differences may be minuscule.

A good transparency will include a color bar to guide printers in achieving fidelity to the image (fig. 28). The color bar is an industry standard and can be matched rather precisely.[11]

Timing can be such that transparencies have to be returned to

11. Heartfelt thanks to Mike Brehm, senior designer and assistant design manager at the University of Chicago Press, whose advice guided me in writing this technical section.

FIGURE 28. A transparency with a color bar. Photograph © Mike Brehm. Permission fee: a signed copy of this book.

their owners and then reordered when the book is actually ready to go to the printer, though today most art publishers are willing to send transparencies to the printer for scanning as soon as they receive them from an author, which helps alleviate the need for extensions.

DIGITAL FILES

What's terrific about digital files is that they don't have to be returned to the lender, eliminating extension fees. Also, digital files are not unique, like transparencies. Replacing them if they are lost or damaged is quick and cheap.

But beware. The catchword with digital files is indeed their "usability." You will want to follow to the letter the instructions provided by your publisher when ordering digital files. Apply uniform format specifications for as many digital images as you can. Your publisher will appreciate it if you submit the images on CDs or DVDs rather than as e-mail attachments.

The accuracy of digital files can be hard to judge because every computer screen is different. One may cause a file to read red, another green. Like transparencies, the best digital files include a color bar. If the color bar is lacking, your publisher may ask you to supply

an image, say, from a book, to assist in matching color at the printer. Most suppliers of digital files do not provide match prints; so if your publisher requests one, it will be your responsibility to find an accurate image for matching.

It's important to know what distinguishes a high-resolution digital file, suitable for use in offset printing, from low-res and medium-res files, which do not offer images sharp enough for display in analog media.

If I order a digital file, what size—how many pixels—should it have?

On the subject of pixels, confusion abounds. Pixels are the tiny bits that make up a digital image. Art Resource, Corbis, and other photo archives offer digital files in a range of formats involving different quantities of pixels.

What authors sometimes fail to grasp is that a digital file has actual physical dimensions, just as a traditional photograph does. With digital files, the dimensions are measured electronically as the number of pixels that, side by side, run the length, width, and depth of the file.

Most printers today require a resolution of 300 pixels per inch (ppi). Using this standard, a high-resolution image of 300 ppi, with a total width-height measurement of 1,600 × 2,400 pixels could be used at a size of 5.3 × 8 inches.

$$\frac{1{,}600 \text{ pixels}}{300 \text{ ppi}} \times \frac{2{,}400 \text{ pixels}}{300 \text{ ppi}} = 5.3 \times 8 \text{ in.}$$

High-resolution images (fig. 29) are loaded with visual information that results in more detail, seemingly continuous tone, and accurate color in the final printed image. In contrast, a low-resolution image of 400 × 640 pixels could only be effectively used for a small reproduction measuring 1.3 × 2.1 inches:

$$\frac{400 \text{ pixels}}{300 \text{ ppi}} \times \frac{640 \text{ pixels}}{300 \text{ ppi}} = 1.3 \times 2.1 \text{ in.}$$

Low-res images (fig. 30) have a normal resolution of 72 ppi. Thus, if you want to enlarge the previous example to a picture size of roughly 5 × 8 inches, you would see that the image degrades.

$$\frac{400 \text{ pixels}}{72 \text{ ppi}} \times \frac{640 \text{ pixels}}{72 \text{ ppi}} = 5.6 \times 8.9 \text{ in.}$$

Low-resolution scans are not terribly useful from a printing stand-point. They are fine as place-holders or to alert a designer as to how

FIGURE 29. A high-resolution file scanned properly at 300 ppi. Note the detail in the circled area. This file is appropriate for offset printing. Provided as a JPEG by the University of Chicago Press Design Department. Fee paid: $0.

FIGURE 30. A low-resolution scan at 72 ppi enlarged to 5 × 8 inches. Note the step (pixilated) characteristic of the image and the loss of detail. Provided as a JPEG by the University of Chicago Press Design Department. Fee paid: $0.

an image should be oriented. And low-res and medium-res scans are acceptable for websites because computer screens display images at 72 ppi. But, to repeat, for fine-art printing, publishers want high-resolution files of 300 ppi.

Authors, hoping to improve low-res images they make at home, often try to increase resolution using the Photoshop software that comes with their computers. The result is almost never satisfactory. Forcing 72 pixels into 300 in the same space simply means that the program adds digital filler around and between the ones loaded with genuine information. The computer guesses what shade and color the newly added intermediary pixels will be on the basis of the actual ones already in the file. The result (fig. 31) is a blurry image. In other words, Photoshop cannot magically bring out visual information that wasn't there in the first place.

File Formats. JPEG is the file format most commonly used by museums and image banks because it compresses files efficiently for easy transport over the Internet. Digital cameras take pictures as JPEGs.

As an author, you need to be aware, however, that the JPEG format degrades an image each time it is saved. You should never open and save a digital image you acquire as a JPEG. Simply turn it over to your publisher, who will convert the JPEG to a TIFF file, which is more stable—though far more cumbersome. In other words, you

FIGURE 31. A low-res scan at 72 ppi, with resolution artificially increased to 300 ppi. The image still lacks detail and is soft (blurry). Provided as a JPEG by the University of Chicago Press Design Department. Fee paid: $0.

don't want to be the one checking the quality of the digital file. Leave it to the professionals.

PHOTOGRAPHIC PRINTS

For more than a century, black-and-white and color prints have been the fodder of magazine and book publishers. Today, as we've mentioned, publishers prefer to work from transparencies when it comes to color imagery, but "glossies" remain perfectly acceptable for black-and-white imagery. In fact, when images are to be printed in duotone (two colors), publishers prefer to receive the base art as black-and-white glossies, all uniformly printed in the darkroom. As with other formats for artwork, the quality of the image on the printed page cannot possibly exceed that of the photograph itself. In fact, it is generally not as good, because photographs are converted into what are known as "halftones" for printing. A halftone is a copy of an image screened in reverse and stripped into the plate that is set up on the press for printing. A halftone gets its name from the fact that it contains only half the tonal range of an original black-and-white print. The quality and density of the ink used in printing compensates somewhat for the loss in tone, but not for all of it. Therefore, the photographs you submit should be of the best quality you can afford: evenly printed with bright highlights and deep shadows, rich in detail.

Publishers like to receive black-and-white prints that are larger than the printed image desired. Thus, if you submit a 4 × 5 in. glossy, the printed image would need to be slightly smaller to maintain quality and sharpness. Generally you should try to send prints in a standard format, 5 × 7 or 8 × 10, on glossy stock. Do not send images printed on matte or uncoated paper. They will appear diminished in the final product.

WHAT ELSE?

To quote Roseanne Rosannadanna, "It's always something. If it's not one thing, it's another." Just when you think you've covered all the bases, here it comes.

Every time I've gotten into trouble, it's been for a silly reason. Once we ordered a photo of a medieval scroll to reproduce on the dust jacket of a book. The image sent to us was black-and-white, and the scroll's owner, a research library, indicated it must be so printed. Manipulation by cropping, tinting, or imposing type over the image was expressly forbidden.

Our designer dutifully laid out the book cover according to the lender's requirements and selected a rich paper stock that was a minute shade off-white in order to simulate the great age of the document. Publishers routinely select paper stock that evokes the time and space of an object's origin. Anyone in their right mind would have agreed that to print such an object on a stark white field would be anachronistic, but when the lending institution received their advance copy of the book and saw the jacket, they were livid, implacable, and quick to remind us that tinting was not allowed. The only way to appease them was to pull the jacket from all the books in our warehouse and reprint it on a pure white stock.

Absurd? We thought so. But in fact, we *had* made a mistake: we hadn't anticipated the problem of "tinted paper." We didn't touch the image but had printed on the wrong color paper and had not maintained fidelity to the reproduction image.

FEES

What is a fair fee? How do I know if I'm being overcharged?

The fee you will be required to pay for an image depends on two factors: whether or not the lender has a stock photo on hand and the commercial prospects of your project, as the grantor sees it.

It is true that arcane subjects cost more to reproduce than popular canonical works: the Louvre possesses multiple photographs of the *Mona Lisa,* but if you want to publish some Etruscan pot, they may have to make a new photograph and will pass a portion of the expense along to you. The system therefore militates against the kind of work that scholars most need to see reproduced. As a historian recently asked me, "Why can't museums cross-subsidize, so

that every crazed soul who has read Dan Brown and wants a microscopically detailed image of the *Mona Lisa* can help pay for monographs on numismatics?" In fact, many museums do this, but even so, if you need an image that requires new photography, be prepared to foot part of the bill.

When it comes to assessing the commercial prospects of your project, you will find that as you move from image to image, the game shifts in strange and goofy ways.

Sometimes you luck out and deal with reasonable people. Some of these people work for artists' rights groups or behind the blue door in the rights departments of museums. Some of them manage artist foundations. Some are collectors. But be prepared; when you move beyond the temperate zone of museums and commercial photo banks, you may encounter a fair number of scalpers, photographers who think they can charge the earth for their grab shot of a famous person. Stand ready to negotiate — try it. Play the nonprofit card, and see if they will accept a more modest sum. These people want money, pure and simple. Most of them will settle for less of it rather than nothing.

Are costs going up?

Yes, in general they are. Case in point, an author recently reported:

> There are 71 prints reproduced in my new book. The Bibliothèque nationale wants $69.01 just for the rights for one seventeenth-century engraving. The last time I requested permission from them to publish a print in their collection, there was no charge. This was just a few years ago. If every holder of a print asked as much as the BN, the total cost to me would have been $4,928.11 for the reproduction rights alone. This of course does not even include the cost of the photographs themselves.
>
> I published a book in 1991 that had 174 illustrations. No more than a handful of the photo sources requested permission fees, and I did not pay more than $100 total.[12]

12. E-mail to author from John Beldon Scott, March 8, 2002.

It certainly costs more to rent a transparency today than it did ten years ago. An art historian I know who is just now finishing a scholarly monograph about the Egyptian collection at the British Museum was quoted a price of £5,000 — not dollars — by the museum for reproduction rights alone for about forty images, not counting the cost of the photographs! Many of these images are in the public domain.

The photo units of the British Museum and the British Library blame Thatcher's budget cuts in the 1980s as the force precipitating them into commercialism and pushing up fees.[13] Of course, such high fees are not unique to the museum world. To publish a *New Yorker* cartoon or a photograph of the 9/11 disaster will very likely cost an author or publisher even more on a unit basis.[14]

To be fair, it *does* take money and time for a museum to prepare a reproduction-quality image of a work of art in its collection and to coordinate the paperwork, record keeping, and logistics of reserving and loaning it out. As Susan Rossen, director of publications at the Art Institute of Chicago, explains, "Most museums have only a tiny fraction of their holdings photographed, and this isn't just because of sheer numbers. To be photographed, objects have to be moved, their condition examined; they may have to be cleaned before a photograph is made; they may have to be unframed and reframed. All of this takes time and staff, not to speak of equipment and supplies."[15] In addition, a museum may want to correct color in press proof, and then there are the tasks of checking the image back into the archive and assessing its condition, though this is less often a concern as lenders switch over to digital files, which can be duplicated and transmitted to users at almost no cost. Nonetheless, permission costs do seem to be going up and the notorious "repro" fees are more pervasive.

13. Ibid.

14. For an all black-and-white paperback specialist book with a print run of 1,500 copies, Terry Smith reports having to pay Gamma Presse $500 for a still capture from Jules Naudet's video of American Airlines Flight 11 hitting the North Tower of the World Trade Center (8:45 am). The book, *Architecture of Aftermath*, was published by the University of Chicago Press in 2006.

15. Note to author from Susan Rossen, received August 15, 2005.

When asked why this is so, those who work behind the blue doors usually cite the demands of executive management to increase revenues across the board to compensate for budgetary shortfalls. Reproduction costs aren't the only thing rising at museums; ticket prices and membership fees are going up too. Anyway, rights workers generally see what they do as a service: they're not lining *their* pockets with the proceeds from licenses and will argue that fees only allow an institution to recoup a fraction of the cost of maintaining an image archive for researchers. For all this, I have a sneaking hunch there is, at the root of some of these transactions, the idée fixe that the art book, even a scholarly one, is a sumptuary good: beautifully printed on heavy, white-coated paper, handsomely bound and jacketed, with a generous trim, giving it a distinguished presence on any coffee table ... thus justifying the extortionate fees that some licensors charge.

NEGOTIATE!

Acquiring images is not unlike buying a car. You can often negotiate a better price.

Returning to our saga of the British Museum: The author I mentioned, having fainted upon opening the bill, has now staggered to her feet, revived by the quick administration of smelling salts, and shot off a volley to the rights manager at the BM indignantly rejecting the £5,000 quote. With an expression of keen displeasure, she counters with an offer of £2,500 flat, which, to her utter dismay, is accepted—no questions asked other than how would she like the images formatted?

The British Museum declined to comment on the transaction when given a chance, but Theodore Feder notes that "ARS will negotiate a volume discount when large numbers of images are involved, and fees are reduced drastically for truly academic publishing."[16] We shall surmise the same holds for the British Museum.

16. "Steal This Image: Museum and Art Book Publishers Wander in Copyright's Wild West," *Publishing Trends*, December 2001, http://publishingtrends.com/copy/0112/0112stealthisimage.htm.

Just as you will want to do some preliminary tire kicking before laying down cash for a car, you should also take the time to shop around for images: if you are making a general observation about the oculus in the dome of Rome's Pantheon, one photograph will surely serve as well as the next, and every self-respecting photo archive owns perfectly decent shots of the view. A search I just conducted netted half a dozen results for basically identical images priced from $50 to $450 for the same rights.

The moment you start trolling the websites of Art Resource, Scala, or Bridgeman, you'll learn that they make it exceedingly easy to order images online but not so easy to get a quick quote for the sake of comparison. For that you'll need to commit to a longer search or to a conversation via e-mail or phone with a representative.[17]

Libraries, on the other hand, often provide a price on the spot when you search their archives online.

When do I have to pay my bills?

It depends. Some lenders will insist that you pay in advance of them sending the image. Others accept payment when a work is published. Some will require checks or wire transfers, though most will accept credit cards. Some artists and smaller archives or libraries will accept a copy of your book in lieu of a fee, so it never hurts to make the offer.

What resources are available for financing book illustrations?

Unfortunately, not nearly enough. CAA gives a small number of grants each year designated to defray illustration expenses. The Mellon Centre in the United Kingdom offers subsidies for projects about British art, and many foundations will support illustration needs for projects in their specific areas of interest. Sometimes you can apply for these grants directly, but you will also need to be

17. Corbis will send you an automatic quote online.

able to demonstrate that your book is under contract or has been accepted for publication by a press.

Some presses will let you borrow against projected royalties to help pay for illustrations, but, given the weak market for most art books, the sum will likely be quite modest. If you are an assistant professor, you may have better luck asking the dean of your college for help. Deans often have discretionary funds in their budgets to support the publication of first books.

If I'm going to reproduce an image from an obscure foreign newspaper, am I better off with the Library of Congress, the Bibliothèque nationale, or the British Library?

Every library has its strengths and weaknesses. But here's a tip: In a matter of minutes, I found identical cartoons from a nineteenth-century Brazilian newspaper available from the Bibliothèque nationale and the U.S. Library of Congress, for $80 and $22, respectively. (The British Library did not possess a copy of the newspaper.) And the Library of Congress will send you a digital file or a print in a fraction of the time it takes to get one from the BN.

Will a private library be more expensive than a public one?

There's no way to gauge this broadly. Private libraries and archives may charge more for common images than public libraries do because they are less likely to have stock copies on file and will have to have new ones made. On the other hand, there is something to be said for the personal touch when dealing with smaller institutions. If you can visit in person and talk to the staff about your project, they may very well cut you a deal—or even allow you to make a photo yourself. Art historian John Beldon Scott tells about visiting the photo archive of *La Stampa*, the major local newspaper in Turin. "The director . . . was at first rather resistant to my request for three items from the archive. The main reason for this was that she had no mechanism for charging me for the reproduc-

tion rights. When I observed that this was really a problem for scholarship, she countered: 'Yes, well, after all, you Americans are the ones who started this.' I could only agree. After much discussion she very kindly gave me the photographs and the rights without charge."[18]

I have permission to publish an image, and the library that owns it has sent a good reproduction. In addition to publishing the whole work, I also want to show a detail. May I isolate a detail from the image and enlarge it? Do I need the lender's permission?

Most institutions place strict conditions on how objects in their collection can be reproduced. They insist on fidelity to the underlying work. Unless you get explicit permission to do otherwise, an image must be published full-frame, without cropping or bleeding. If you want to manipulate it (including enlarging a detail), make this clear when you contact the rights holder.

What other restrictions do lenders place on images?

Credit lines must be precise and are designated by granting institutions in exactly phrased language. The image may appear in the book's interior, but not on the cover or in advertising. Sometimes color proofs from the printer must be submitted to the grantor for approval. This almost certainly adds extra expense and time to the publication schedule. At the publishing house where I work, we try to allow for this. For example, when we were preparing a book about Matisse, we had to deal with a rather complex basket of approvals. The Matisse estate insisted on reviewing press proofs for the four-color images, as did many museums who had loaned transparencies. It took three rounds of proofing to satisfy all parties and required that we secure loan extensions for several images, meaning—guess what?—additional fees.

18. E-mail to author from John Beldon Scott, March 8, 2002.

If I can download an image from a website, is it mine to use?

Unless the owner of the website expressly states that you may use an image for *any* purpose, probably not. Usually images in "Web museums," while dandy for research, are encrypted with an owner's watermark and are hardly ever of sufficient quality for publication.

Years ago I purchased a slide of a drawing from the museum that owns it. Since I already possess the slide, may I use it in my book?

Technically, it depends on the terms you agreed to when you purchased it.

"Wait a minute! Didn't you hear me? Are you listening? I told you, I *own* the slide. I paid cash for it in the Met gift shop in 1984; I even still have the receipt. I use it all the time. I've taught whole seminars around it. Listen, I published a groundbreaking essay on this Dürer drawing back in 1992, for God's sake, which, by the by, lest you forget, is certainly in the public domain, even by the Picassos' standard. Now you're telling me I have to go back to the Met for permission? *No* way. The publisher didn't tell me to get permission to publish the slide back in 1992, so I sure as hell won't do it now."

With all due respect, you probably first published that slide back when institutions and social practices were more forgiving than they are today. As we've seen, museums sell slides for express purposes and with specific restrictions that are stated either on the object or on the bill of sale (whether you notice them or not) at the time of purchase.

It's true that some institutions will politely turn their heads at the feigned ignorance or self-styled privilege of certain éminences grises who have graced their galleries over the decades and who helped make the famous works in their collections even more famous.

But chances are if you're reading these lines, we're not talking about you. In any case, you should discuss the situation with your publisher, who will no doubt have an opinion on the matter—not to mention the last word.

Can I take an image from a book?

This is one of the slipperier slopes in intellectual property culture. So it is at the risk of alienating half the art world that I'll venture to report that recent case law suggests you can mine an image from a book if the photograph is of a *two-dimensional work* such as a painting or drawing that is in the public domain. You can also mine 2-D works that are in copyright *if* the copyright holder doesn't say you must obtain an image from a specific source as a condition of the license.

However, if an image mined from a book seems like an impostor, you are right. It is many generations removed from the original work of art. There are at least five intermediary versions between you and the brushed-on pigment of that *demoiselle*'s derriere: at minimum, there is a transparency, a printer's scan and color separations, and then press plates and the printed image. Then here you come with your measly camera to initiate a new cycle at yet another remove. At the same time, you ache for an image brimming with veracity. The results of such an enterprise used to be pretty dismal, but the wonders of new technologies may soon propel us into a sunnier era.

Printers now have the wherewithal to scan images directly from the printed page and to eliminate the unsightly screen (or moiré) pattern (fig. 32). (In offset printing, ink is forced through a fine-mesh screen as it is laid down on paper to produce an image.)

Publishers still prefer that you provide reproductions in conventional formats, but some are willing to scan from books, even though it can mean they have to pay slightly more to produce the separations for printing.

All the same, for now, as I've said, there are trade-offs. Don't expect the printed image in *your* book to be any better than the one you are copying. When it comes to color, you are almost certainly dealing with a printed image that has slightly different values from the original artwork. For accuracy, you are safer renting a transparency, the quality of which is guaranteed by the lender.

FIGURE 32. Screen pattern in printed image. Provided as a JPEG by the University of Chicago Press Design Department. Fee paid: $0.

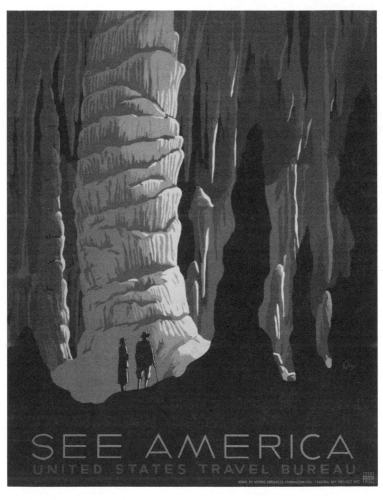

FIGURE 33. Alexander Dux, *See America* (1936–39). Library of Congress, Prints and Photographs Division. Reproduction number: LC-USZC4-4243. This WPA work is in the public domain. The image was secured as a JPEG from the Library of Congress. Fee paid: $0.

11 * *A Society of Ownership: See America*

AT THE OUTSET of his second presidential term, our Mr. Bush introduced another snappy sound bite into the civic lexicon: speaking into a microphone, he announced that ours is to be an "ownership society." The aim of this new project, he said, is a renewed sense of purpose, personal responsibility, and empowerment to determine one's own future. The president's message was brimming with so many references to Emersonian self-reliance and was delivered with such brio, with such a spirit of inclusionism, that it took most of the skeptics listening to National Public Radio a couple of seconds at least to wonder how on earth he was going to achieve this wonderful new deal, this democratic, prosperous ownership society—and then he told us.

Working hand in hand with enlightened corporations, we will privatize public services and assets. The conviction that widespread prosperity will flourish in a soil of rightness derives from the sanguine philosophy of Adam Smith et al., and if the president has his way about it, we'll soon see an escalation of privatized health care, retirement services, and education, all popping up to thrive in a field of fertile dung.

The question that goes begging is: Will the privatization of national assets actually lead to inclusion? Has it ever? Do you recall having ever trudged up the path to a stranger's front door, jangling your little UNICEF jar, to see the door flung open before you and,

greeted with hospitable cheer, found yourself ushered inside with the jovial imperative to "Join the party! Get yourself in here"? Or has history not demonstrated more times than we care to count that the result of intent privatization is likely to be a world of closed doors? Blue doors at that.

It hardly needs mentioning that we have been moving in this direction for some time with the steady deregulation of utilities, erosion of anti-trust laws, and softening of FCC regulations. And less regulation means we can now always be on the lookout for yet more public assets to privatize—or, rather, to privateer.

For the moment, there are still some things left related to our national heritage that we can use freely. But do it now, don't dawdle. The open domain in our nation is filling with improvident interests.

So what's free? Thousands of works by the U.S. government[1] that are now in the collections of the Library of Congress. Other items have been gifted to the library without restriction, and this means that, as one of the People, you own them already. If you want to publish one of them, you only have to pay a modest use fee for the Library of Congress to send you a print.

The Library of Congress is also the official repository for countless works in copyright. Check the library website (www.loc.gov) to ascertain the precise status of an image. The website will tell you if permission needs to be obtained from a copyright claimant and, if so, how to reach them.

But you'd be surprised to discover what isn't in copyright: Ansel Adams's Manzanar War Relocation Center photographs, which he gifted to the library without restriction; a collection of portraits by Carl Van Vechten; and of course the WPA (Works Projects Administration) images that were made by artists and photographers on the U.S. payroll during the Great Depression. Many important artists worked for the federal WPA.[2] Dorothea Lange's emblematic *Migrant*

1. 1976 Copyright Act, sec. 105.

2. Many state governments also commissioned WPA projects. Those works may or may not have been copyrighted by the artist.

Mother was made in 1936 on assignment for the Farm Security Administration (FSA), a division of the WPA, which means she was working for you (well, okay, maybe for your grandmother). You own this great photograph. Lange's personal work, on the other hand, is controlled by her estate and will remain in copyright well into the twenty-first century.

Now to details: As of this writing, you can order a black-and-white glossy of Lange's photograph from the Library of Congress for as little as $25. Many of the images can be downloaded from the library website free and without restriction on use. It is how I obtained the image below (fig. 34).

How long such largesse will last is anyone's guess. Already one can notice the squeeze — tender appellatives pinned to old masters with the imprint of proud ownership: "© Board of Trustees, National Gal-

FIGURE 34.
Dorothea Lange,
Migrant Mother
(Destitute pea-
pickers in California.
Mother of seven chil-
dren. Age thirty-two.
Nipomo, California.)
Library of Congress,
Prints and Photo-
graphs Division,
FSA-OWI Collection,
LC-USF34-009058-C.
This public-domain
image was down-
loaded from the
Library of Congress
website as a TIFF file.
Fee paid: $0.

lery of Art, Washington."[3] One only need click on the Smithsonian website to see image downloading limited to "fair use" for the purpose of education or research and expressly forbidding publication without the permission of the institution. Yes, when it comes to our own treasures, the trend in this country, in this ownership society, seems to be toward locking them down.

In Great Britain, government productions have long been treated as precious assets held in copyright. They include such riches as BBC programming and the collections of the British Library. There are, however, small but significant concessions being made in the United Kingdom for a broader interpretation of fair use — or "fair dealing," as the British term it. For several years the BBC has been working to build a Creative Archive that will be available to British citizens, who will be able to download archive clips for "non-commercial use, [to keep] on their PCs, manipulate and share them, so making the BBC's archives more accessible."[4] The idea, we are told, is to encourage creative enterprise by British citizenry. The materials would ostensibly be free to artists, researchers, and educators, all seen as members of a "creative" rather than "commercial" class of user.

The BBC cites as its model the Creative Commons project (CC) in the United States, established by Stanford law professor Lawrence Lessig.[5] Creative Commons strives to restore the balance between

3. See Douglas R. Nickel, *Dreaming in Pictures: The Photography of Lewis Carroll* (San Francisco: San Francisco Museum of Modern Art and Yale University Press, 2002), 4. The copyright page includes the following credit for a copy photograph of a work by Charles Dodgson (*Alexandra "Xie" Kitchin*, 1869; vintage albumen print) in the collection of the National Gallery of Art: "pl. 3: photo by Dean Beasom, © 2001 Board of Trustees, National Gallery of Art, Washington." This catalog copyright page is a veritable primer of current copyright practices and sleights of hand.

4. "BBC Creative Archive Pioneers New Approach to Public Access Rights in Digital Age," press release, http://www.bbc.co.uk/pressoffice/pressreleases/stories/ 2004/05_may/26/creative_archive.shtml, May 26, 2004.

5. The Creative Commons project (http://creativecommons.org) is supported by the MacArthur Foundation, whose initiative to protect the public domain is discussed in chapter 5. Duke University law professor James Boyle is another architect

private interests and the common good. It offers a new, flexible approach to managing intellectual property: its most inventive feature is a departure from the black-and-white, either-or system for determining if a work is in copyright or in the public domain. Lessig's point is that being generous by extending a license to the world—subject to conditions—does not compromise the right of the owner to tailor those conditions or to license a work when the opportunity presents, and that making work readily available may even generate lucrative opportunities to license it. The driving force behind the CC seems to be a genuine concern for culture's health, and the effect so far has been salutary. Virginia Rutledge reports that, according to former Creative Commons executive director Glenn Otis Brown,

> since Creative Commons made "flexible" copyright a viable option, in December 2002, more than five million individual works—images, texts, music, film—have been posted on the Web, with links to notice of the permissions given by their owners, in advance, to potential users of the works. Not every work is available free of restrictions (or of charge); that isn't the point of flexible copyright. And of course, it is not immediately clear how this digitally based system might be applied in real space. No matter. For this moment, it's the big idea that is needed.[6]

Be that as it may, Creative Commons has its limitations: there may be millions of items posted to the system, but if it doesn't retrieve the exact artwork a scholar needs to illustrate his argument, its vast assets are, from his perspective, trivial.

It is also the case that the Creative Commons project has drawn some fire. Some legal activists criticize the CC as relying too heavily on the sovereignty of the author, without adequate provision for fair use. Still others see it as an apocalyptic sign that the end of modern

of Creative Commons. Boyle is a founder of the Center for the Study of the Public Domain at Duke University; the center also receives funds from the MacArthur Foundation.

6. Virginia Rutledge, "Fare Use," *Bookforum*, April/May 2005, 33.

intellectual property law draweth nigh, that such an enterprise will launch an avalanche of "unfair usage."

To be blunt, that's what can happen when hungry societies are dominated by corporate monopolies, when access to useful information is too tightly controlled. We've seen how surveillance by major copyright holders is increasing. As Lessig points out in *Free Culture*, "On the Internet . . . there is no check on silly rules, because on the Internet, increasingly, rules are enforced not by a human but by a machine: Increasingly, the rules of copyright law, as interpreted by the copyright owner, get built into the technology that delivers copyrighted content. It is code, rather than law, that rules. And the problem with code regulations is that, unlike law, code has no shame."[7] As Walter Benjamin wisely counsels and history confirms:

> If the natural utilization of productive forces is impeded by the property system, the increase in technical devices, in speed, and in the source of energy will press for an unnatural utilization, and this is found in war.[8]

Today in the new millennium, partly in reaction against the steep costs associated with accessing and storing great quantities of information, librarians at some of the major research institutions across America are on the rumble, rolling out a version of fair use in a push to make any and all published intellectual property available without charge to what could turn out to be a potentially unlimited number of users. The librarians have effectively made a case to broaden the definition of fair use by arguing that if a library owns (or borrows) a copy of your book or article, it should be able to digitize and freely distribute electronic copies within the university com-

7. Lawrence Lessig, *Free Culture: How Big Media Uses Technology and the Law to Lock Down Culture and Control Creativity* (New York: Penguin, 2004), 148.

8. Walter Benjamin, "The Work of Art in the Age of Mechanical Reproduction," in *Illuminations: Essays and Reflections*, ed. Hannah Arendt, trans. Harry Zohn (New York: Schocken Books, 1969), 242.

munity. In the University of California system, theoretically this could mean up to 180,000 individual copies disseminated without recompense to the publisher and author.[9] Yes, librarians are trading in their tweed for battle fatigues. They are the Che's of the information age. And they may just succeed for the simple reason that their declared mission, to disseminate knowledge, lacks the venal motive of financial *gain*. On the other hand, such heroics do serve to mitigate *expense*; and taken together, these factors make for a powerful movement that some say threatens, for better or worse, for good or for ill, to topple the teetering tower of conventional copyright law as we know it.[10]

Moreover, as Lessig ably demonstrates, what a book *is* has changed dramatically in recent times, straining the very economic and cultural fabric that supports our whole copyright system. Traditional copyright law is built upon the Cartesian conceit that books (or any printed text for that matter) exist in quantifiable space-time, that the number of copies of a work is finite, and that each copy occupies a discrete few cubic inches of the planet's surface. Once that copy is sold at a legitimate point of sale (in a bookstore, for example), there is nothing to prevent it from being resold on the used-

9. The list of research universities involved in this effort is growing rapidly. Early activists included the librarians at MIT and the state university systems of California and Texas. For more on the digitization of books by libraries and by Google Print (recently renamed Google Search), see Robert S. Boynton, "Righting Copyright: Fair Use and 'Digital Environmentalism,'" *Bookforum*, February/March 2005, 16–19. Boynton's article also reviews a number of recent books on the culture of copyright in the digital age. On digitizing motion pictures and distributing them through academic libraries, see Scott Carlson, "The Revolution Will Be Digitized: Libraries Create Online Archives to Preserve and Share Film and Video," *Chronicle of Higher Education*, April 29, 2005, A30–32.

10. The situation has become more complicated since Google, a commercial enterprise, entered the scene. Google has launched a program whereby it provides content, in the form of scanned books and journals, to libraries (for a fee). Google has joined in the chorus crying "fair use," but the courts have said that one cannot step into another's "fair-use shoes"—that is, Google cannot bootstrap from the fair-use arguments of others. We shall see how this plays out.

book market, loaned, or given away. Thus a single copy makes its way in the world.

Such freedom of exchange is challenged in the new coded environment, where every use of a work can now be monitored, counted, and controlled, where a downloaded copy cannot be borrowed or transferred, edited or excerpted, and certainly not resold.[11] The direction in which new legislation is trending is based on the idea that every time you open an e-file, you are making a new copy—and new copies are subject to the rules of copyright law.[12]

However, as libraries brandish fair use with zeal, as copies are distributed to students via e-reserve in downloadable formats, copies of books (and, yes, their illustrations) are beginning to circulate via the Internet, like it or not, legal or no.

The framers of the Constitution realized that financial development was the key to generating growth. But the news is filled— fraught—these days with stories of big business on the move, gobbling up content wherever it puts its heavy hand or sensitive probe. "What is to become of us?" ask alarmist media—which are themselves acute and purposeful productions of big business. Dystopia is imminent and there's no going back! Even this book, I admit, is driven by a rhetoric of doom.

Enough already, time to switch gears.

The problem, as Lessig reminds us, is black-and-white thinking. Weaned on a system of supply and demand, we perceive ourselves all to be jockeying for position in the same contrived space of competing ownership and use. Right now, owners of intellectual property—and this includes owners of visual material—hold tight to the belief that *it* is all being taken away from them when mostly it

11. Some providers even have policies that a work may not be read aloud. Boynton cites an Adobe e-book warning on its edition of *Alice's Adventures in Wonderland* in his article "Righting Copyright," 18. For a summary of technical solutions to protecting creative material online, see Peter Cassidy, "Burning the Jolly Roger: Technical Solutions for Armoring Puts Creatives Back in Control," Triarche Research Group, http://www.triarche.com/commentaryipprot.html.

12. Lessig, *Free Culture*, 139–47.

is simply being *used.* We need to become better at distinguishing the difference, meaning we need to be realistic about markets.

Not everyone is a fan of Lessig, but I am, at least when it comes to the spirit of his enterprise. I think he's on to something, and I'd like to put forth a modest proposal, building on his, for balancing market conditions when it comes to visual intellectual property.

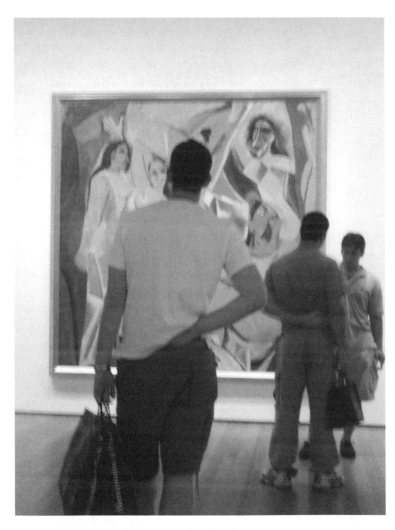

FIGURE 35. Crowd viewing Picasso's *Les demoiselles d'Avignon*, Museum of Modern Art, New York City, 2005. What caption would fairly represent this photograph? Should I have obtained permission from the Picasso Administration to publish it? Photograph © Kimberly Pence. Image provided as a JPEG. Fee paid: $0.

12 * *A Supplicant's Manifesto*

LET'S SUM UP. We've been over the issues, and we've looked at examples. We've sketched out some reasonable practices for acquiring images and the permissions to publish them. I've tried to simplify the legal issues as best I can for lay readers, but how does one simplify and still accurately represent the tangle of issues that are routinely described as "a thicket"? I'll be the first to admit that my treatments won't satisfy everyone; sometimes we seem to operate in a system of mutually exclusive interests between various parties to intellectual property. For all that, I'm willing to bet that most of the readers of this book stand convinced that the societies with the best futures are those that somehow manage to strike a decent balance between individual and collective needs. For whatever reasons and choices we've made thus far, we are trying to keep pace in an intellectual property system that is acutely out of measure, for we live in a society that, even intellectually, seems grounded almost exclusively in buying and selling. As thoughtful people, our goal in this shrinking intellectual and artistic world should be not to pit ourselves one against the other but to come together.

What can we do to help coax this fragile ecosystem back into balance? More specifically, what can we do—right here, right now—to turn the market for visual intellectual property around? Perhaps we have overlooked ways to put the tools of commerce to good use. As a book editor, I am often led to wonder: Does publication make intellectual property worth more or less?

I recently attended an event at the University of Chicago where the school's president, Don Randel, remarked that there was no better statement of the qualities and values of the university put before the public than the books and journals we produce at the University of Chicago Press. Surely the same holds for museums. Students see images in books that take them to museums. Make no mistake: *Les demoiselles d'Avignon* is an enormous draw for the Museum of Modern Art. Seeing it featured in books—and thus constantly reinvigorated in cultural and intellectual life—keeps those admission fees coming and the turnstiles clicking. Ditto Georges Seurat's *La grande jatte* at the Art Institute of Chicago. Double ditto the *Mona Lisa* at the Louvre.

Of course, after hundreds of years, the reputation of the *Mona Lisa* is well established. But culture is a shared activity, and many other artworks—in fact, the vast majority—need to be put forward regularly, over and over, through publication in print or online to reinforce their relevance to culture. Reproductions make art worth more, not less.

There is no question that the soaring cost of acquiring illustrations and the permission to publish them has become such an impediment to art publishing that it exerts a profound drag on the field. Clearly, scholars—including those at museums, which also develop publications—need some relief from the onerous burden of permissions. At the same time, the rights of individual creators must be protected. Both are crucial to a cultural environment that thrives on creative enterprise (or purports to), but how to reconcile the two? In particular, what can scholars—as a collective—do?

First of all, in this consuming world, scholars must remember that they, too, are members of the creative class—and, moreover, that as users, as customers, they possess enormous power. There are today countless purveyors of visual content, much of it identical, so why should it be a seller's market? Since duplicate images have remained such hot commodities in what must be acknowledged as a saturated field of industry, we should look to other markets that have been transformed by recent advances in technology: the book market, for example. Online stores that can be used as search engines like

Amazon and Alibris have transformed the book market, especially the used-book market, from one dominated by antiquarian booksellers to one easily exploited by buyers, which has driven the prices of all but the rarest tomes down.

Could something of the sort work for images? Especially for images of artworks in the public domain? Authors hunting for illustrations could type a list of needs into a website search engine and have vendors return a range of options and prices to them, including formats and incentives for batch orders. As vendors start to compete for business, there might be online specials ("two images for the price of one if you order today!"), free shipping for orders over $200, and so forth.

Right now, it's easy to browse various photo archives online. But it's not so easy to figure out who might be offering the best deal. Many archives want you to place an order before they tell you how much it will cost. And some archives assert restrictions on use of images, regardless of whether the works are in copyright or in the public domain, by means of warning notices that may or may not reflect appropriate intellectual property laws.

Granted, it wouldn't be easy to convince big corporate players like the Bridgeman Art Library and Corbis to compete online for your business, but small vendors seeking wider exposure and individuals who possess photos they have made themselves or purchased without enforceable restrictions could at least get the project started. With time, this idea would gain momentum.

Obviously, this model cannot apply to copyrighted artworks, nor should it. Those still need to be cleared with artists or their agents — but such a system would reduce charges and help to put paid to the notorious "repro" fees that some institutions assess when you publish public-domain objects in their collections. As mentioned, repro fees are fees over and above the cost of the actual scans or photos of the artworks; their effect is to claim a copyright-like right to restrict and control use, often asserted through clauses in the image rental contract. Sometimes, as discussed in chapters 5 and 6, that claim is warranted, but very often it is not.

What else can we do to turn the market for visual intellectual

property around? We can draft a Supplicant's Manifesto, with calls to action on three levels: first, things that you as an individual can do, then activities for small groups, and finally actions by nonprofit and professional organizations geared to address larger issues of policy and law.

For the Individual

Point 1 is obvious: Pictures don't serve every cause. Don't publish ones that you don't need.

Point 2: If you *must* use certain images, never do anything to encourage property owners to increase their fees. Sometimes getting an image is like working a jumble sale—there is often room to negotiate. Try it.

Point 3: Describe the nature of your project up front to lenders. Many of them do, I readily concede, consider whether the permission you seek is for a scholarly or a more commercial book when they calculate a fee. And most are aware of the erosion in the market for art books, but you should take every occasion to remind them of it.

Point 4: Offer lenders the chance to invest in your project. Suggest a fee scheme scaled to profits. Silly? Yes. But it's silliness with a point. Tell the lender you are prepared to set aside a significant chunk of your income from sales of the book to be shared by everyone who contributes to the project. Let's say your book will be two hundred printed pages. If the lender's image appears in a full page in color, she or he would be entitled to 1/200 of your royalties. For a typical art study, this would pay out to the princely sum of maybe five dollars over the book's life. Of course, the return on investment for a quarter-page image in black-and-white would be far more modest.

Point 5: If you are working with a university press in the United States, encourage private holders of copyright to file for a tax deduction in exchange for a waiver of fees. If your publisher enjoys a nonprofit status, the waiver might qualify as a charitable contribution. (Be sure to check with your editor before you make such an offer.)

Point 6: Be flexible about your illustration program. Ask your

editor to furnish a list of image lenders who tend to charge either reasonable or exorbitant fees. With apologies to Freud: Sometimes a French Gothic spire is just a French Gothic spire, and one image will serve as well as another. *Point 7*: Build transparency into illustration captions. If a lender insists that you assert an inappropriate copyright, note it in the caption along with the lender's required credit line. Also note how much you paid for the image and the permission to publish it.

For Small Groups

Point 8: Establish a "copyright police" for infringement on the public domain by lenders, especially regarding copyright claims on reproductions of two-dimensional artworks. Perhaps we need a bulletin board on the Internet where we can discuss prices for images from various lenders and note restrictive or beneficial practices.

Point 9: Establish a search engine based on a competitive model, like Alibris, that makes it easy to buy, sell, and trade images at cut-rate prices.

Point 10: Support university presses in lobbying for more lenient laws that would allow them to qualify for educational—that is, noncommercial—status. This would entail a benefit to you by creating more flexible allowances for fair use.

For Nonprofits and Professional Organizations

Point 11: Museums can help by reviewing their rights and permissions policies in light of their overall mission. They can also compare what it costs them to support a rights unit against the revenue it produces and consider relaxing their control of public-domain objects in their collections.

Here, I must say, there are signs of a thaw. The British Museum, I'm told, has decided to waive reproduction fees for images that will appear in books with print runs of fewer than 750 copies. Granted, it's the rare publisher who fires up the press to print so few copies,

but even so, we can hope the museum's policy is a harbinger of better times to come—and that fees are headed in the right direction: down!

Other institutions are also revisiting their rights and permissions programs: Kenneth Hamma, at the J. Paul Getty Museum, has proposed placing the museum's public-domain holdings on the Internet in high-resolution scans suitable for downloading and printing—for free—on the grounds that the public domain *is* the public domain. If you want to put their Lansdowne Herakles on a tote bag and sell it, that's your business. Taking the statue out of the museum, so to speak, and copying it—despite Benjamin's admonition—doesn't make the original work any less valuable or interesting. In short, the statue is not being used up. It is simply being used.

Of course, the core holdings of the Getty and the British Museum are in the public domain—not to mention that the Getty is one of the richest museums in the world and the British Museum is heavily subsidized by the British government. But other more modestly endowed establishments, such as the Courtauld Institute of Art, are also reconsidering their permissions policies in light of the needs of scholars and publishers.

Point 12: Scholarly organizations should support efforts to solve the problem of orphan works, specifically proposals, that call for sensible limits on remedies for infringement. The beauty of that idea is that one does not need to be a legal genius to grasp it, and if incorporated into copyright law, it would clear a path for more interesting and diverse discourses on art and other aspects of visual culture.

Point 13: The professional organizations of art historians should issue statements of best practices related to fair use and be prepared to stick to them. In the end, the discipline must take up for itself and its own expressive means. Remember that the Society for Cinema Studies drafted a paper calling for the fair use of film frames in 1992—that was fourteen years ago. To date, to the best of my knowledge, the position has not attracted litigation. And the reason it hasn't is simple: courts *want* to uphold the fair-use doctrine. It is not

easy to win a judgment against someone who has legitimately exercised their right to make use of someone else's intellectual property, within reasonable limits. The scs has demonstrated what enormous benefit can come of a concerted, collective action to take a strong position. Survival of the fittest translates into safety in numbers.

The theologian Mark Taylor said recently: "Money and markets do not exist in a vacuum but grow in a profoundly cultural medium, reflecting and in turn shaping their world."[1] Nowhere is this more evident than in the culture of permission. We have reached a moment in research and in scholarly publishing when it is crucial to consider why, given the surfeit of visual content on offer, the image continues to be a pawn in a seller's market.

It's time for this to change.

1. Mark Taylor, *Confidence Games* (Chicago: University of Chicago Press, 2004).

13 * What Did It Cost?
A Summary of Fees for This Book

THIS IS an art book. Granted, of a different stripe than many members of the species *codex artifex*; nonetheless, illustrations are key to the successful exegesis of its argument. What do they say about a picture versus a thousand words?

It was decided in an early meeting with my editor, Linda Halvorson, that writing this book and acquiring the illustrations and permission to publish them should constitute an exercise in legal transparency: under the circumstances, to have approached the task otherwise would have been a dereliction of duty.

Because the book contains only black-and-white illustrations and so much of the material is already available online and in publications, we took as many shortcuts as good practice and the law would allow in assembling the images and the requisite permissions to publish them. When public-domain works were available free online in an acceptable format, we took them. In one or two cases, we resorted to scans from books. We were exceedingly conscientious in obtaining clearances for any work that could be construed to be in copyright according to U.S. law; and this goes for the one telltale orphan.

Here, then, is a summary of the expenses associated with publishing this book. I encourage other authors to persuade publishers to provide relevant information in their books and journals as well, either in captions or as addenda.

- Copyright fees paid to artists, photographers, and estates, either directly or via rights agencies: $1,198.68
- Use fees paid: $312.50
- Total fees paid: $1511.18
- Number of images for which the artist, photographer, or other image provider waived fees: 18
- Number of images possibly involving inappropriate secondary copyright claims: 6
- Finally, the number of images for which permission to publish was denied: 1

[*date*]

[*address*]

Dear Sir or Madam,

I am writing to request your permission, as copyright holder, to reproduce one of [*your works / work by an artist you represent*] [*specify black-and-white or color*] entitled [*name of the image and artist*].

This image will appear in a book by [*author*] currently entitled [*title*] to be published by the University of Chicago Press (a nonprofit department of the University of Chicago) in the [*season*]. This is a scholarly undertaking that will reach a specialized academic audience. The expected print run will be _____ copies.

I am requesting reproduction permission to cover both interior illustrations and other forms of illustrations connected with this volume, including but not limited to advertising, publicity, and direct mail, or other similar uses, but excluding use as a cover illustration. I ask that you grant nonexclusive world rights for the reproduction, as part of this volume only, in all languages and for all editions [*minimum rights needed would be world rights, English language*]. [*Indicate expected size of reproduction: ¼ page, ½ page, etc.*] [*If applicable include this sentence: Please note that I have the image/s and am only writing to request permission to reproduce them.*]

If you are the rights holder, may I have your permission to reprint the above work? Please indicate how you would like the University of Chicago Press to acknowledge this work. If you are not the rights holder, do you know who might be?

Please sign and return this letter to me. Please contact me if you have any questions regarding this request.

Yours sincerely,

[*author's signature and name*]

Approved: _____ Date: _____
 (*signature*)

Sample copyright permission letter

[date]

[address]

Dear Sir or Madam,

I am writing to request an image [*specify black-and-white or color transparency*] from your collection entitled [*name of the image and artist*].

This image will appear in a book by [*author*] currently entitled [*title*] to be published by the University of Chicago Press (a nonprofit department of the University of Chicago) in the [*season*]. This is a scholarly undertaking that will reach a specialized academic audience.

I am requesting permission to use the image as both an interior illustration and other forms of illustration connected with this volume, including but not limited to advertising, publicity, and direct mail, or other similar uses, but excluding use as a cover illustration. I ask that you grant nonexclusive world rights for the reproduction, as part of this volume only, in all languages and for all editions [*minimum rights needed would be world rights, English language*]. [*Indicate expected size of reproduction: ¼ page, ½ page, etc.*]

Please sign and return this letter to me along with the image in question. Please contact me if you have any questions regarding this request.

Yours sincerely,

[*author's signature and name*]

Approved: _____ Date: _____
 (*signature*)

Sample use permission letter

Art Requiring Permission	Permission Status	Grantor	Coverage	Fee / Books	Art Status / Format	Color Proof Required	Size Restrictions	Due Date
Use this space to record the complete caption information for the illustration, including Artist, Title, Date, Location, and any information that may be required by the lender to be included in the caption.	Copyright: Secured or To Come? Use: Secured or To Come?	From whom is permission required?	Write "All" for all languages and editions, worldwide; or list restrictions.	1. Amount of fee 2. Number of gratis copies required	1. List item as "In" or "To Come" 2. Describe Format: • Color transparency • B/W photo • Slide • Digital file (.pdf, .tif, .jpg) • Other?	Does the lender require approval of color proofs?	Does the lender stipulate the size of the reproduction? ¼ page? ½ page? Etc.	Must the material be returned? If so, when?

Material Requiring Permission	Status	Grantor	Coverage	Fee / Books	Status / Format	Color Proof Required	Size Restrictions	Due Date
Please include full credit information, including any credits required by Permission Grantor								
Fig 1 — Henri Matisse, *Odalisque with Red Culottes*, 1921. Oil on canvas, 26¾ x 33¾" (67 x 84 cm). © Succession H. Matisse, Paris / ARS, NY. Musee National d'Art Moderne, Centre Georges Pompidou, Paris, France	**Copyright** ☒ In ☐ To Come ☐ N/A **Use** ☒ In ☐ To Come	ARS	World distribution, English language	$110 / 2 copies	**Status** ☒ In ☐ To Come **Format** ☒ Color transparency ☐ B/W photo ☐ Slide ☐ Digital file ☐ Other	☒ Yes ☐ No	½ page	6/20/05
		Art Resource	World distribution, English language	$95 / 2 copies				
Fig 2	**Copyright** ☒ In ☐ To Come ☐ N/A **Use** ☒ In ☐ To Come	VAGA	World distribution, English language	$130 / 2 copies	**Status** ☒ In ☐ To Come **Format** ☐ Color transparency ☒ B/W photo ☐ Slide ☐ Digital file ☐ Other	☐ Yes ☒ No	½ page	
		Art Resource	World distribution, English language	$30 / 2 copies				
Fig 3	**Copyright** ☐ In ☐ To Come ☒ N/A **Use** ☒ In ☐ To Come	Public Domain	---	---	**Status** ☒ In ☐ To Come **Format** ☐ Color transparency ☒ B/W photo ☐ Slide ☐ Digital file ☐ Other	☐ Yes ☒ No	½ page	
		Art Resource	World English	$100 / 2 copies				

Sample permissions log and summary

Sources: Image Banks and Artists Rights Organizations

IMAGE BANKS AND SEARCH ENGINES

Art Resource, Inc.
536 Broadway, 5th floor
New York, NY 10012
Tel: (212) 505-8700
Fax: (212) 505-2053
E-mail: requests@artres.com
www.artres.com

The Bridgeman Art Library (London)
Tel: 44 (0)20-7727-4065
E-mail: london@bridgeman.co.uk
http://www.bridgeman.co.uk/

The Bridgeman Art Library
International (New York)
Tel: (212) 828-1238
E-mail: newyork@bridgemanart.com
www.bridgeman.co.uk

Corbis
E-mail: sales@corbis.com
www.corbis.com

Creative Commons
543 Howard Street, 5th floor
San Francisco, CA 94105-3013
Tel: (415) 946-3070
Fax: (415) 946-3001
E-mail: info@creativecommons.org
http://creativecommons.org

Fotosearch Stock Photography and Stock Footage
21155 Watertown Road
Waukesha, WI 53186-1898
Tel: (800) 827-3920
E-mail: contact@fotosearch.com
www.fotosearch.com

Getty Images
Tel: (800) 462-4379
www.gettyimages.com

Picsearch AB
Liljeholmsvägen 30B
SE 117 61 Stockholm
Sweden
www.picsearch.com

U.S. Library of Congress
101 Independence Ave, SE
Washington, DC 20540
Tel: (202) 707-5000
www.loc.gov

ARTISTS' REPRESENTATIVES

In the United States

Artists Rights Society
536 Broadway, 5th floor
New York, NY 10012
Tel: (212) 420-9160
Fax: (212) 420-9286
E-mail: info@arsny.com
Website: www.arsny.com

Visual Artists and Galleries Association
350 Fifth Avenue, Suite 2820
New York, NY 10118
Tel: (212) 736-6666
Fax: (212) 736-6767
E-mail: info@vagarights.com

In Great Britain

Design and Artists Copyright Society (DACS)
33 Great Sutton Street
London EC1V 0DX
Tel: 44 (0)20-7336-8811
Fax: 44 (0)20-7336-8822
E-mail: info@dacs.org.uk
Website: www.dacs.org.uk

For artists' representative organizations elsewhere in the world, consult the CISAC website: www.cisac.org.

Further Reading

Becker, Gary, and Richard A. Posner. *The Becker-Posner Blog*. http://www
.becker-posner-blog.com.

Bollier, David. *Brand Name Bullies: The Quest to Own and Control Culture*.
Hoboken, NJ: John Wiley and Sons, 2004.

Boyle, James. *Shamans, Software, and Spleens: Law and the Construction of the
Information Society*. Cambridge, MA: Harvard University Press, 1997.

Boynton, Robert S. "Righting Copyright: Fair Use and 'Digital Environmental-
ism.'" *Bookforum*. February/March 2005, 16–19.

Brown, Michael F. *Who Owns Native Culture?* Cambridge, MA: Harvard
University Press, 2003.

Buskirk, Martha. *The Contingent Object of Contemporary Art*. Cambridge, MA:
MIT Press, 2003.

Center for the Study of the Public Domain (Duke Law School) website.
http://www.law.duke.edu/cspd.

College Art Association. Committee on Intellectual Property. *News*. January
2004. http://www.collegeart.org/caa/news/2004/Jan/CIPcommittee.html.

——. "'Orphan' Copyrights." http://www.collegeart.org/orphan-works.

Harper, Georgia K. "Copyright Crash Course." University of Texas System.
http://www.utsystem.edu/ogc/intellectualproperty/cprtindx.htm. Last up-
dated 2001. (This is an excellent introduction to the subject of intellectual
property. Because the last update was in 2001, some of the information may
not be current.)

Jaszi, Peter. "Goodbye to All That: A Reluctant (and Perhaps Premature) Adieu
to a Constitutionally Grounded Discourse of Public Interest in Copyright
Law." *Vanderbilt Journal of Transnational Law* 29 (1996): 595.

——, participant. "Virtual Reality, Appropriation, and Property Rights in Art:
A Roundtable Discussion." *Cardoza Arts and Entertainment Law Journal* 13
(1994): 89.

Keller, Bruce P., and Jeffrey P. Cunard. *Copyright Law: A Practitioner's Guide.* New York: Practising Law Institute, 2004.

Landes, William M., and Richard A. Posner. *The Economic Structure of Intellectual Property Law.* Cambridge, MA: Belknap Press of Harvard University Press, 2003.

Lessig, Lawrence. *Code and Other Laws of Cyberspace.* New York: Basic Books, 1999.

———. *Free Culture: How Big Media Uses Technology and the Law to Lock Down Culture and Control Creativity.* New York: Penguin Press, 2004.

———. *The Future of Ideas: The Fate of the Commons in a Connected World.* New York: Vintage, 2002.

———. *Lessig Blog.* http://www.lessig.org/blog.

Litman, Jessica. *Digital Copyright.* Amherst, NY: Prometheus Books, 2001.

Rose, Mark. *Authors and Owners: The Invention of Copyright.* Cambridge, MA: Harvard University Press, 1993.

Rutledge, Virginia. "Defining Fair Use in Visual Art Research Sources and Strategies." *Legal Reference Services Quarterly* 17, no. 4 (1999).

———. "Fare Use." *Bookforum.* April/May 2005.

———. "Free for All." *Bookforum.* October/November 2004.

U.S. Copyright Office. http://www.copyright.gov.

Vaidhyanathan, Siva. *Copyrights and Copywrongs: The Rise of Intellectual Property and How It Threatens Creativity.* New York: NYU Press, 2001.

Woodmansee, Martha, and Peter Jaszi, eds. *The Construction of Authorship: Textual Appropriation in Law and Literature.* Durham, NC: Duke University Press, 1994.

Index

Page numbers followed by an *f* or a *t* refer to figures and tables, respectively.